Field Test

Field Test
Jackie Nickerson

KERBER ART

Essay
Aidan Dunne

Writing in the mid-1930s about what sparks a poem, Elizabeth Bishop suggested that one factor is "the feeling that the contemporary language is not equivalent to the contemporary fact; there is something out of proportion between them, and what is being said in words is not at all what is being said in 'things'." The photographs we see in Jackie Nickerson's *Field Test*, and the perplexing entities they often feature, emerge from just such a sense of disproportion, or perhaps disjuncture. Except that in this case, for words read images. The artist is spurred to devise a visual language equivalent to a set of facts that eludes conventional representational strategies. There is a materiality to her images, an integral sculptural component, just as Thomas Demand's photographs feature an apparently familiar reality that is actually, in each case, a three-dimensional paper construction. Nickerson's images too convey a reality that is in the process of reconstruction.

Collectively, it is clear that her photographs occupy and reflect a world of global, industrialised production and consumption. They respond to the fact that technology is reshaping the world, and the people who inhabit the world, in subtle and less subtle ways. Mention the impact of technology, and images of automation, of slick robotic production lines, and algorithmic marketing tools come to mind. But of course technology is disruptive across the board, favouring the rich at one extreme and engendering the gig economy, drawing in armies of menial workers, who struggle to survive, at the other. Hi-tech merges with and generates lo-tech, co-opting humans at every turn.

There are, mostly, single individuals in the photographs, which could be described as portraits of a kind. But we can never quite pin down the identity of the subjects who, to put it mildly, remain elusive. Perhaps they are not even subjects in the sense we usually think of subjects. Sometimes it is almost as if they are metamorphosing, and have been caught at a stage of transformation, as they are remade by the workings of the world around them, scrambling to adapt with whatever is to hand. In their indeterminacy, their fraught illegibility, they are icons of anxiety, shielded and isolated.

Visibility is invariably scrambled or thwarted. Intervening layers, veils, screens, sheets, frames, boxes, distort or displace pictorial convention.

Any hint of distinctive personality, for example, or of coherent identity, is wrapped, buffered, packaged, concealed, suppressed. The figures are both startlingly visible and yet, in many respects, invisible. Everyone, we know, has a distinct personality. Clothing and many other aspects of appearance can express personality and fix identity in terms of gender, age, social status, cultural affiliations and role - one's role often being signalled by a uniform, formal or casual.

In Nickerson's images, however, a mass of accoutrements and devices shield and neutralise standard signifiers of gender, race, personality and more. The materials draped, bound, taped and knotted, serving as improvised barriers and coverings, are generic, anonymous and ubiquitous. They are mostly plastic in one form or another. If these are modes of disguise, they are not necessarily elective. Often the gear worn appears protective, against what it is not clear: risk of infection, of contamination? There's certainly an urgent, improvisatory quality, an underlying air of crisis, to the way materials are brusquely enlisted and patched together.

Protection, in the form of a barrier, works both ways. Protect the wearer, or protect what the wearer is in contact with. Equally, visibility can be strength or weakness; see and not be seen. One might be visible, say, for reasons of surveillance, monitoring and management. Beyond that, for those doing the monitoring, it can be better that you're forgotten if, for example, you are on the labour rather than the customer side of the economic equation. No one wants to know too much about you. Nickerson addressed exactly this state of affairs, the world of remote, invisible labour, serving distant, on-demand markets, in her project and book *Terrain*.

Operating at a level far deeper than overt surveillance, a battery of communications, entertainment and commercial technologies means that digital invisibility is much more difficult to achieve and is even aggressively discouraged. It takes a lot of energy and ingenuity to become and remain digitally invisible. People do attempt it. One must discard a great deal of technology, and crucial aspects of the data that validate your official, bureaucratic identity. There are people who have set about devising DIY clothing and coverings that deflect surveillance devices, aiming for a kind of digital camouflage.

While it's just over a century since the first mass-produced plastic, Bakelite, was created, plastics have quickly become virtually infinite in form and function. From small, hard utilitarian objects to vast, flexible sheets, plastics are universal and dispensable, but stubbornly durable. Magically protean, they collectively, largely invisibly, make up a kind of polymer grid that enfolds and may well choke the planet. The presence of waste plastics extends from the incalculable dispersion of micro-beads to vast cluttered expanses of fragmentary debris, floating islands and archipelagos. But we remain enslaved to the sheer versatility of plastics; they have become indispensible.

There is another kind of grid, one formed by digital technologies, that permeates and, it is no exaggeration to say, shapes our lives. In this boundless technopolis, citizens are increasingly defined by their role as consumers, flattered with the illusion of choice and themselves traded as exploitable commodities by data harvesters. The cultural theorist Fredric Jameson characterised rampant commodification, when areas of life previously within the sphere of the personal are monetised, as symptomatic of late capitalism. As when, seduced by the technologies of communication, individuals become hapless marketers, consumers who are themselves traded.

How is it that the enhanced connectivity enabled by digital technologies might serve to push people apart? The technology that seemed to promise so much in its early days has, in the hands of monopolistic tech giants, delivered something else again. Devices funnel and reinforce preferences and opinion, muffling debate, encouraging self-absorption and divisiveness, diminishing critical thought, while yet maintaining the illusions of agency and community. To be sure, the consumer might enjoy some material advantages, but within unsuspected and distorting constraints.

These Field Test images arrive, and they are slightly disturbing, as though they reach us from an uneasy future that is already forming around us: this is where we are headed. We may not quite recognie this future becoming present, but a lot about it is curiously familiar and relatable. It is as though these images speak a language we are already learning to follow, even though we are not, as yet, fluent speakers.

Conversation
Dan Thawley
Jackie Nickerson

Dan Thawley The concept of a field test has roots in medical science and the testing for loss of vision. It could also relate to products being used for the first time in the environments they are destined for. What does 'field test' mean to you?

Jackie Nickerson It's a medical reference. It's an eye test that involves looking into a large white dome where there are random flashing lights of various intensity and size. It's a test to check how much peripheral vision a person might have lost. The loss of vision is usually imperceptible on a day-to-day basis, so Fields, or a Field Test, is a scientific way of measuring how much we actually see as opposed to how much we think we see.

DT This work sees a more active intervention in the spaces and the bodies of your subjects than in most of your work. With that comes a general feeling of disconnect and isolation. What is your personal relationship with isolation? Do these images reflect this, or are they a statement on the experience of others?

JN Yes it's personal but it's also a universal theme: a creeping isolation. It addresses new kinds of stress and commodification, the environment, speciesism, the waste, the pressure, the mandatory compliance, the lack of privacy. I guess you could say it has a universal identity, like a collective smothering. It's a kind of psychological snapshot or chronicle of a whole generation of our consciousness.

DT Does the identity of your subjects hold any consequence in these images, if their defining features are predominantly concealed? Were they chosen as blank canvases, or with diversity in mind?

JN They are very specific blank canvases. The sitters were chosen because of their proportions, scale, and height. It was a rather brutal casting process.

How long can someone stand still? Can they shut down and not project or perform? Are they claustrophobic? Can they relate to what I am creating? Do they have patience? Tolerance? I asked people whom I knew.

DT Whilst your work has often incorporated a curiosity in synthetic and natural materiality, *Field Test* sees a more implicit conversation with the human form and materials as barriers, masks, insulation and protection. How did you arrive at this conceit?

JN I wanted to control the content so I researchedand chose all the components before putting them together. That meant stepping out of the actual world and into a 'made world'. I think part of that decision was about the photographic process - awareness about control, both of the sitter and the photographer. But it also becomes a question of how much control we relinquish on a day-to-day basis, about how technology and commerce trains us to think in a certain way.

It's about cause and effect. Materiality plays a part here - it speaks of how what we use on a daily basis will have an effect on our psyche and even on our physical lives. So in a way, it's a natural progression from my book Terrain. It's a question about how we choose to live, and what long-term effects those choices may have on us. It seems like nature works in an incremental way, so if you're not paying attention, things will have changed irrevocably and there will be nothing you can do about it. The choice of materials is very important.

DT The materials implicated in your images span a wide variety of agricultural, medical, and industrial usages – they evoke the codes of safety equipment and uniforms, transport and waste disposal, food packaging and even the studio tools of photography itself. What was the process involved in selecting these intermediary materials – functional mediums that serve mostly as protective and insulating barriers – and applying them to the human body as decoration and artifice?

JN I am obsessed by certain materials. Plastic is one of them. I like to take mundane, everyday domestic items and put them in a different context. It's not for decoration – I'm asking questions. I've always been obsessed by supermarkets. The cheaper the better. I remember when I was about 14 years old taking the labels off all the food tins in the house and putting them on my bedroom wall. I have no idea why. I just thought they were interesting.

I began thinking about this series in 2014 when *Time* magazine sent me to Liberia to cover the Ebola care workers. The trip made me think about a lot of things. For this, specifically, it made me think about distancing, the duality of plastics and about human interaction. Functionality in a crisis. I saw how valuable plastics were, how the barrier PPE created was lifesaving and enabled doctors, nurses and carers to work.

I will always remember one of the doctors disrobing after leaving the Ebola ward. It was a careful ritual. A meticulous choreography of purpose and safety. First this comes off, then we roll this piece over this piece, then we pull from the top down etc. Each person did their own clean up. It reduced the risk. And I looked at the PPE, that fragile yet essential thin layer of plastic that enabled health care workers to do their job. I witnessed how communal effort can unite but disease can isolate. The lack of facial recognition, the inability of family members to visit, the isolation wards, the loneliness in death. Learning to live in another man-made, made for purpose world.

Since the Covid-19 pandemic, this has become more universal than ever. But on the other side, we can see how plastic appears in every part of our lives. And it's going to be on the planet forever. And we keep making more and more of it.

DT Less portraiture and more sculpture, the human body becomes a canvas for these other objects and layers that cover and distort the figures. For you, what is the importance of revealing human features as opposed to suggesting them, exposing them or distorting them?

JN I suppose there's a difference between identity and character. Do we need to see the features of a person in order to identify them? Or is a suggestion enough? I think on a very basic level our brains are programmed to try to work out if we are looking at a person or an inanimate object. Do retailers, online shops, insurance companies, politicians, corporations, social media companies think of us

as individuals – as their fellow citizens? Or do they think of us as consumers? As commodities? That's a question. Capitalism works because the bottom line is about profit and loss and individuals are irrelevant. Data research attempts to use all of us to target how we all spend our money. So, how are we dealing with the new reality of being invisible? Now we are beginning to understand how things work and how we are being commodified through systems of big data.

DT There is a universality and banality to these images that place them in predominantly transitory or industrial spaces – a barren field, a grey corridor, greenhouses, airport lounges. How do you reconcile the theme of isolation when bringing communal spaces like airports into the visual conversation?

JN All the airport spaces are actually airside spaces, prohibited to the public – we can only watch from a distance. I think of airports as non-spaces. This is in reference to the French anthropologist Marc Augé's 'spaces of transience' where human beings remain anonymous and spaces don't hold enough significance to be regarded as 'places'. Like any transitory space - the subway, bus stations - there's an edge, you have to be alert. It's public but isolating at the same time. It's a place where we don't really feel relaxed about starting conversations. People are kind of shut down.

There's the personal space issue. Uncomfortable proximity to strangers, waiting in line, security checks, checking in, standing in line again and again. Everyone pretending to be so certain of everything. There's a general feeling of anxiety, of nervousness. Squashing, squeezing, confinement. The regimentation, the orders from security. We are processed. We are subdued. We are compliant. We are anonymous. And this communal space has created this isolation.

DT How do your images of nature under human control correspond to your theme? What is their rapport with the portraits?

JN This whole series is about a kind of collective trauma. The idea that everything is connected, that what we eat and how we produce food is an essential part of life. When we change nature, we change our reality. Today we are alienated from nature. Commercial farming is destroying the natural world, so everything that technology touches in our lives is changing us – from the way we grow our food to the components we choose when making things.

Do you think there will be a time in our lifetime when we ask ourselves 'do you remember rivers'? How do you balance the memory of a planet when it doesn't look like itself anymore? Agriculture – the rural idyll – is long gone. Replaced by miles of plastic serviced by human-less robot ploughs and harvesters. Are our perceptions changing?

As such, I would say the common thread throughout is synthetics. Commerce. Personal choices. Everything is being squeezed, suffocated, controlled – pushed to the edge of what it can tolerate to produce the best yield before having a negative (in the sense of money) or fatal effect. Look at how farmers push their animals to the edge of use. Profit does not have a morality. Mammon is king.

DT The metaphor of the screen and of the photo-within- a-photo is recurring in this body of work. Images appear filtered behind glass, printed and re-photographed in-situ, isolated in plastic bags and the victim of pixelisation and distortion from the computer screen. Is this a comment on separation and distance?

JN Yes, it is a comment on separation and distance. Are we looking at photos of sculpture, or photos of photos? I'm asking the viewer to look at the photo in a different way. When a photograph as an artefact isn't the primary object, ie, when it becomes integrated into another entity, then it changes the context of the original photo. Is a photo of a photo still a valid document? Does the displacement of a photo change its meaning? Do we trust computer images more than physical documents?

DT There is an indubitable sense of the unfinished and of process itself in certain images. Materials askew, multiple views that reveal underpinnings and structures, repetitive forms that reveal opposing perspectives. Was there ever a goal

within this project to achieve an accomplished image? Or was the process the point?

JN A made thing, a uniquely single thing, has its own agency. So if there's no end use to a mask, a structure, a container, then any or all of the components have the freedom to be organically themselves. In this context, there is no such thing as unfinished. An object is what it is. Only when end use or the commodity of something come into play, then an object has to be finished, to serve a function, to be perfect with every millionth replication. Like a light bulb or a clothes peg. If it has no functionality then it can be anything you want it to be. It can mean whatever you want it to mean. It's also about the process – that's important. But really you just know when it's right, when it's complete.

DT Though this is a new body of work, there are discernible elements to these images that refer back to your own canon – notably the series *Terrain*. What was the purpose of returning to certain familiar territories here?

JN I feel like this is a natural progression for me. Certainly it's informed by *Terrain*, which was about the effects of the physical and chemical processes of the material world and the almost alchemical effects these have on the people who grow food for the farming industry. It registers the psychic and physical after effects of work in the landscapes and on the farmers.

In *Terrain*, the photographs utilise portraiture and landscape to present an idea of the synergy between the natural world and the human world, recognising the integration of the person and their produce and environment. The images bring together the elements of raw and manufactured materials, and the people who work with them, to create figures that appear camouflaged by their produce, creating a hybrid figure.

DT Apart from isolation, these images could also induce feelings of claustrophobia. Is this intentional?

JN Yes.
Squashed, squeezed, crushed, compressed, confined, subdued.

DT I also see a reflection on the fetishisation of certain materials like latex and rubber and their rapport with the human body, as well as the perversion of innocent objects - inflatable toys, coloured cellophane - into suffocating shells and chaotic cornucopias of debris. For you, where do you draw the line between the statement of the material imposed on the body and a place where the body is almost superfluous – lost amongst the detritus?

JN I think about the weaponisation of identity, and commodification. Are we all being suffocated by the demands of commerce, by social media, by the need to comply? Are we being suffocated by the need for security? And on top of that the burden of being ourselves, the burden of the drudgery of everyday life. There's the mess, the stuff, the negotiation, the ordinariness.

Should we choose to live by recognising our personal needs rather than striving to live by the unwritten rule of having the 'perfect life'? What is underneath all the perfection, the commodification? We all need a kind of neurological elasticity to cope. And now with the Internet, our every move, our every journey, our every purchase and our every transaction is being monitored and collated. Forever. What I am asking is 'are we being re-purposed? Is that our role in society?'

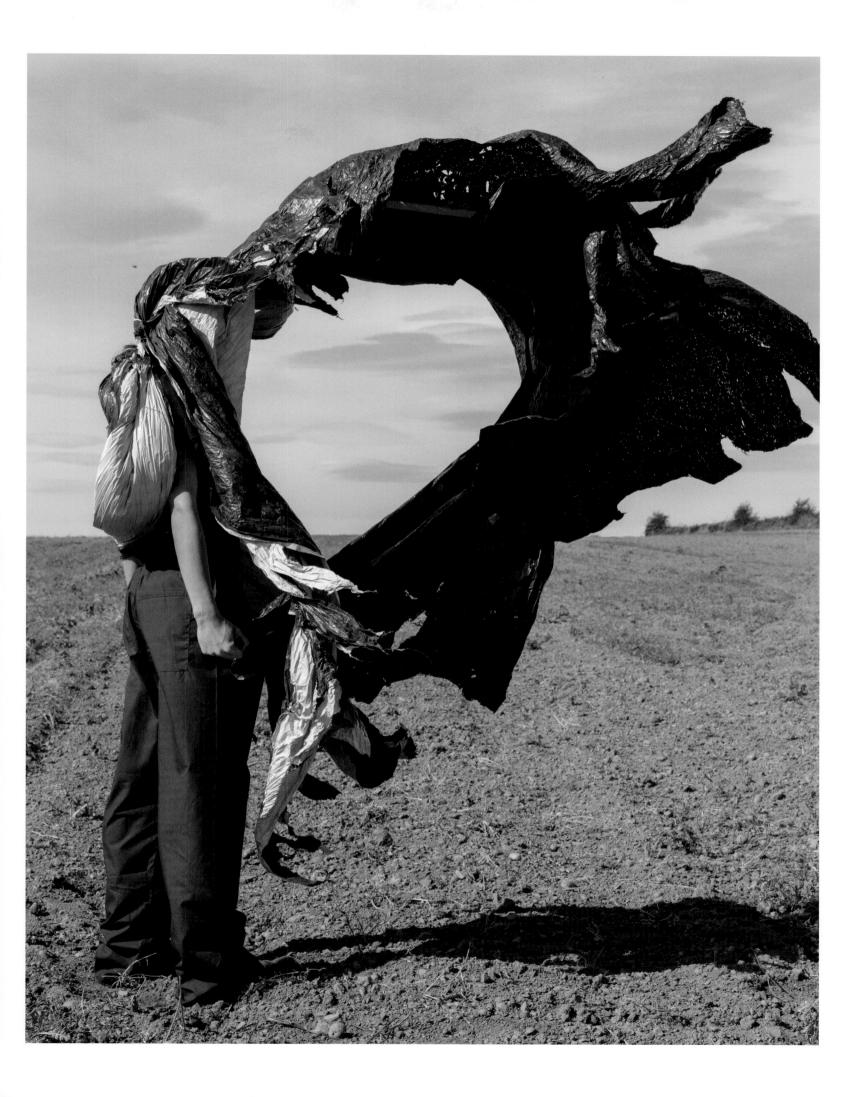

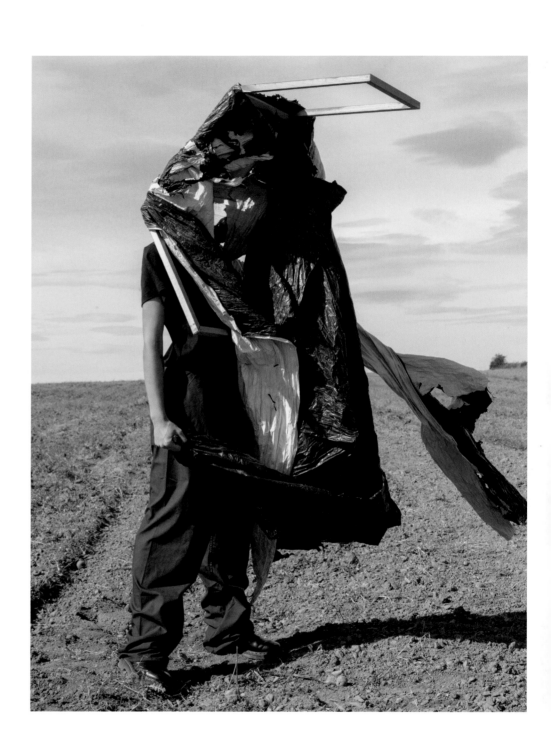

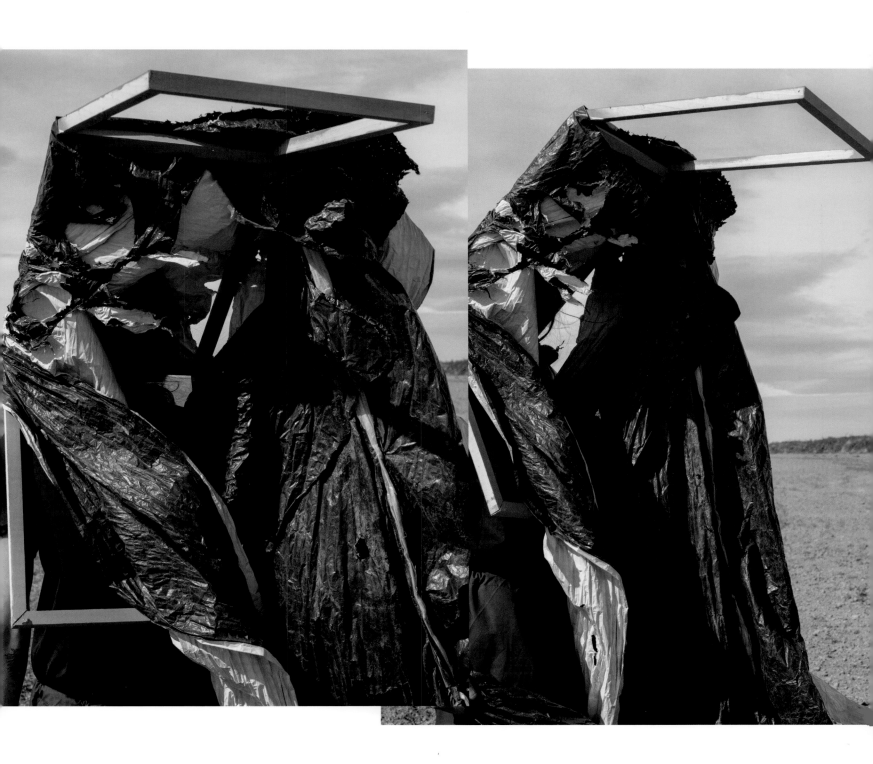

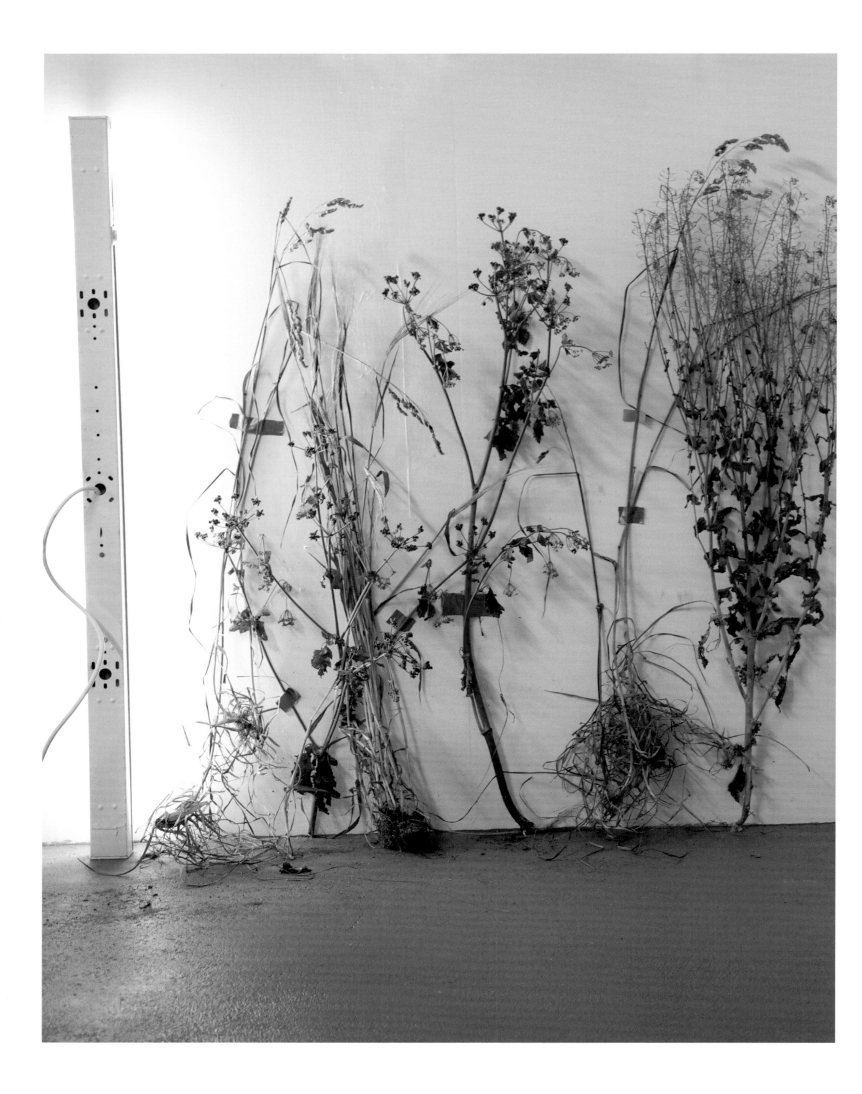

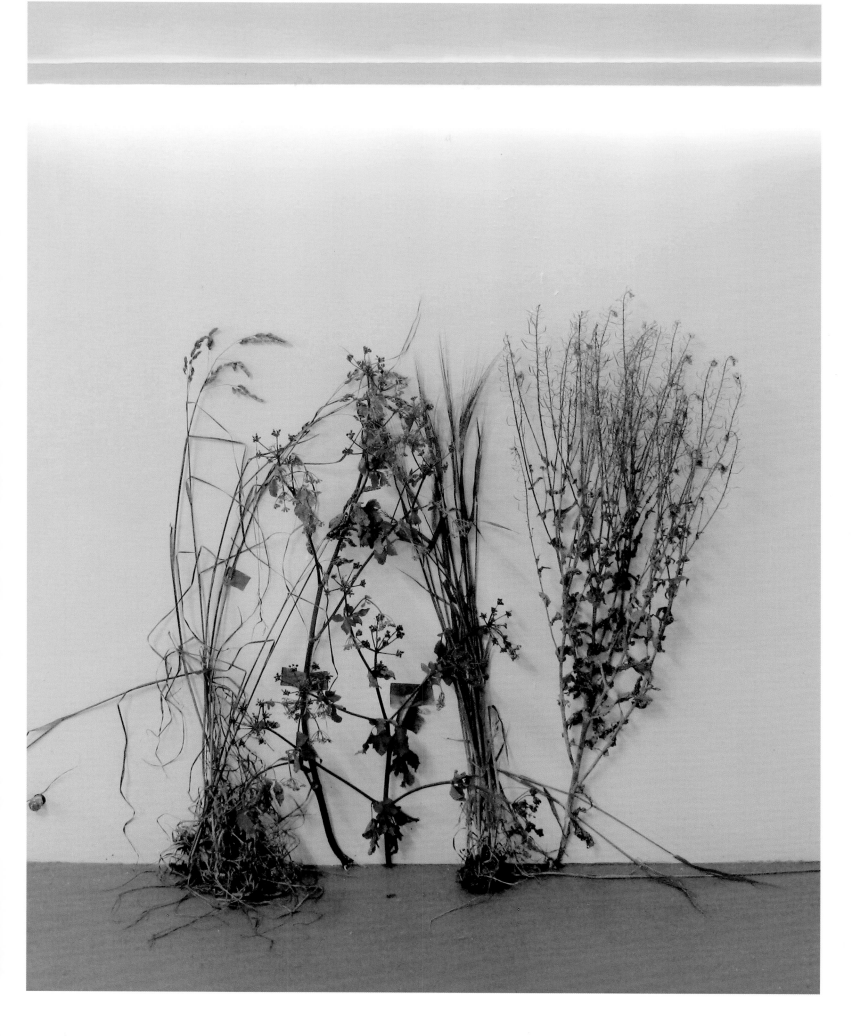

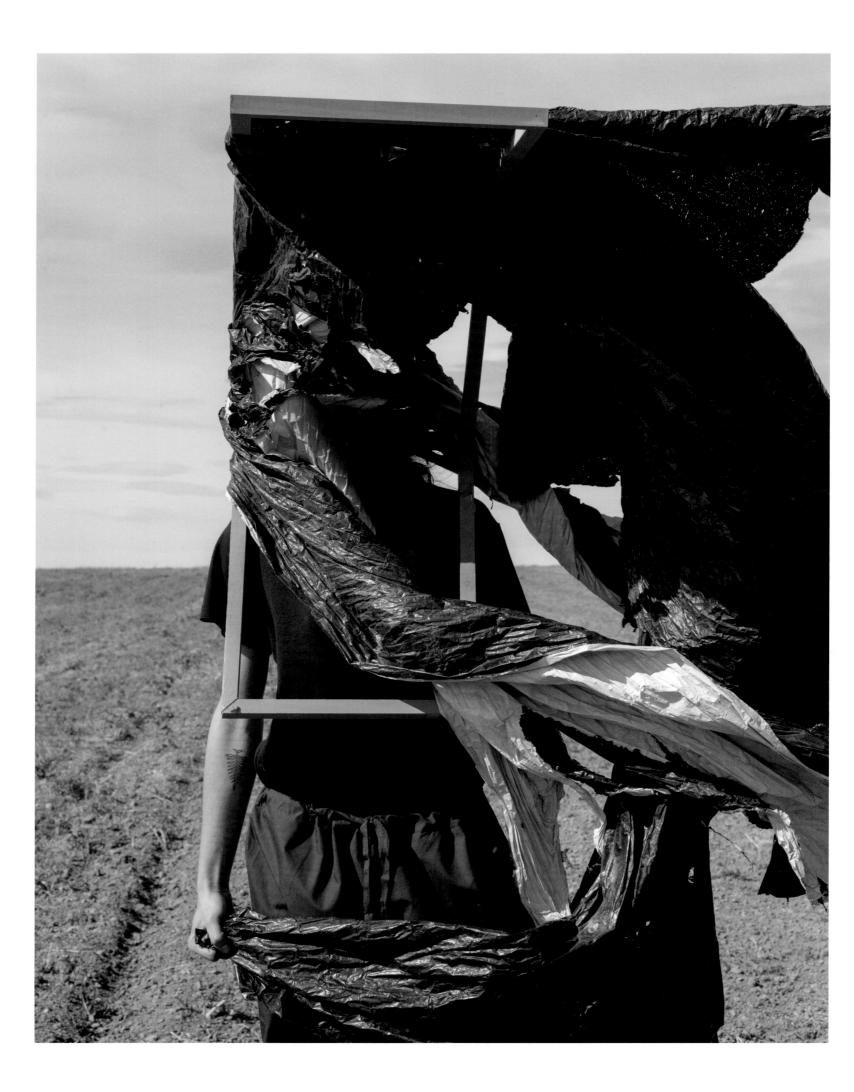

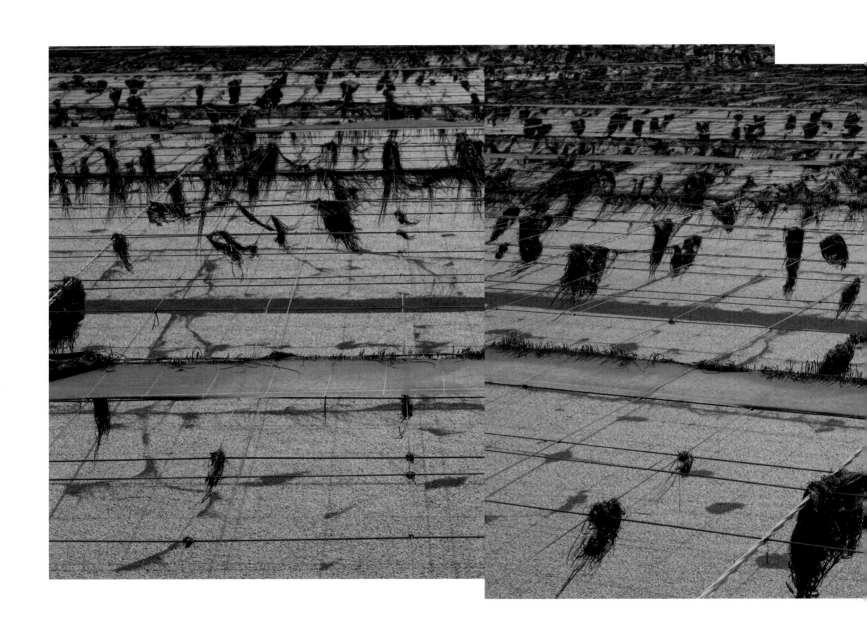

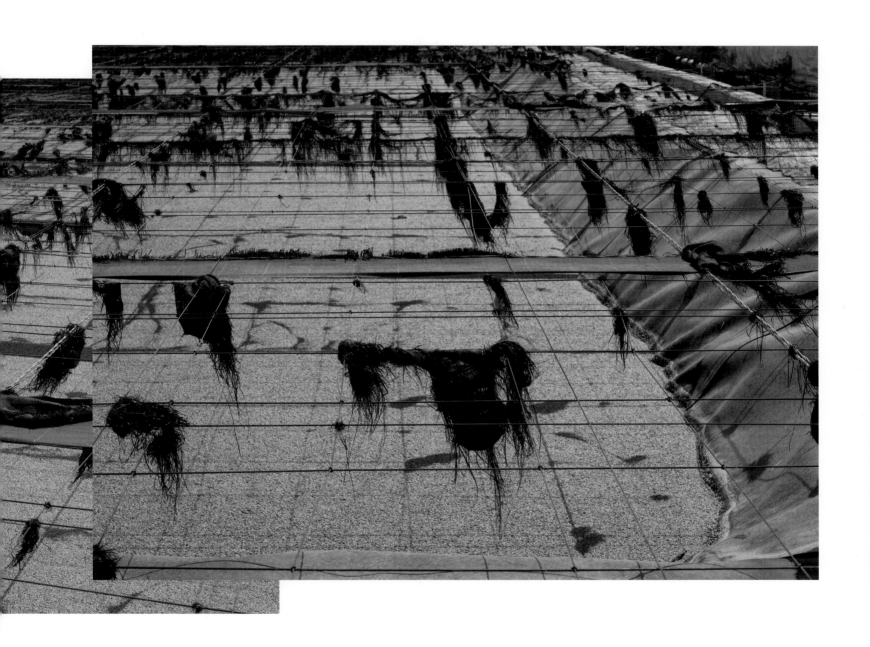

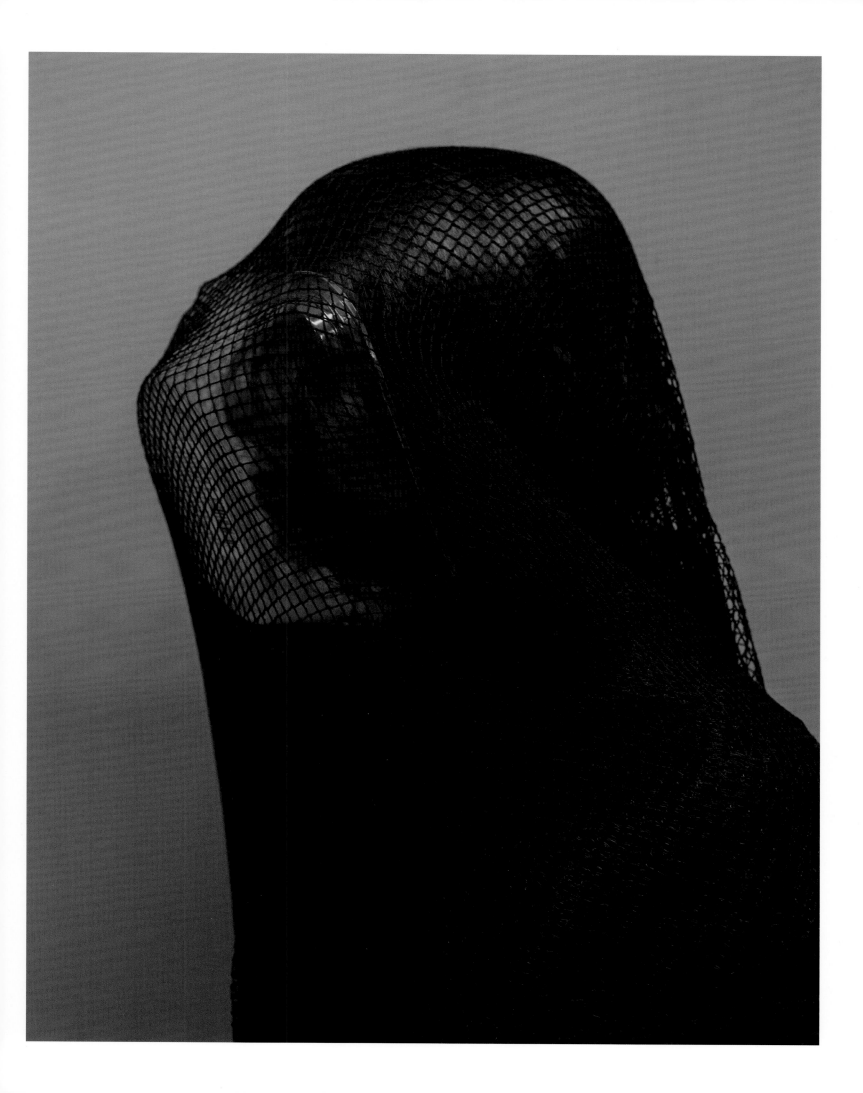

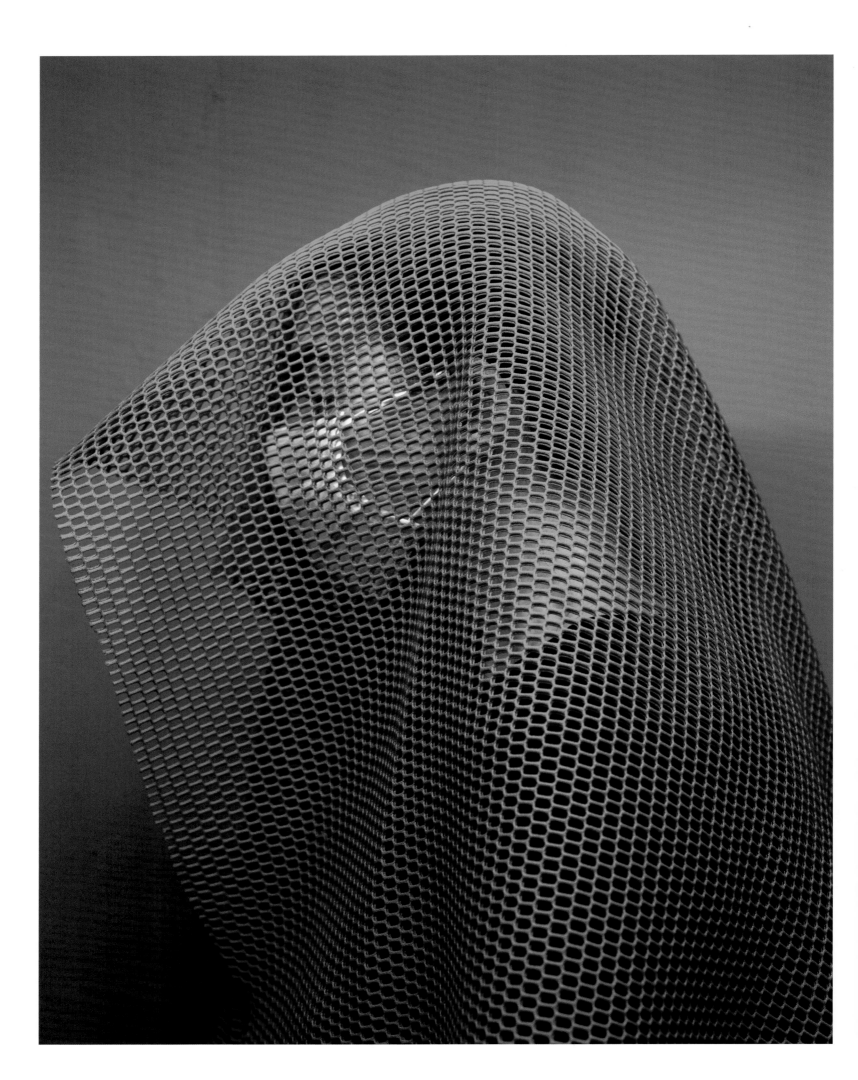

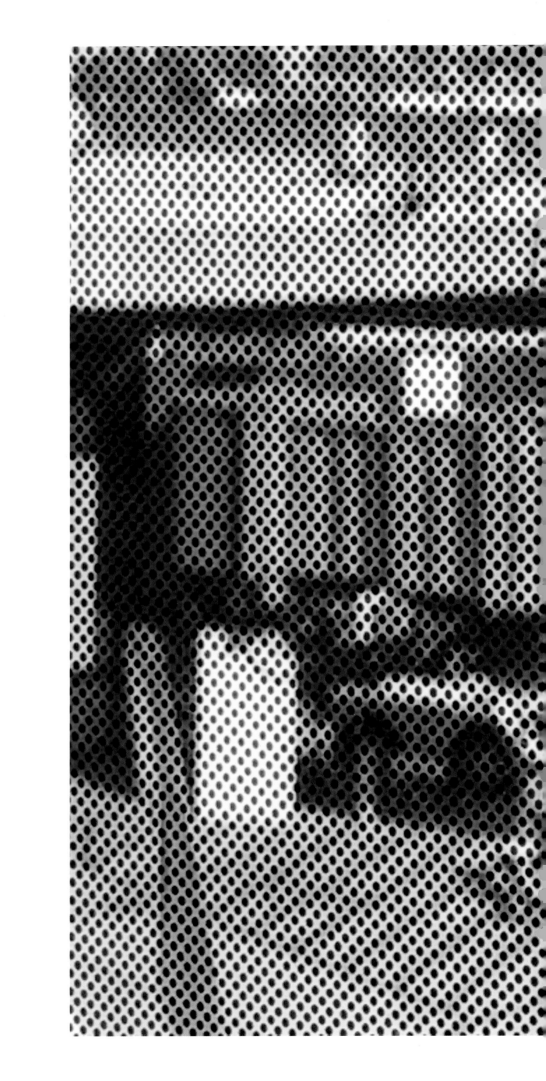

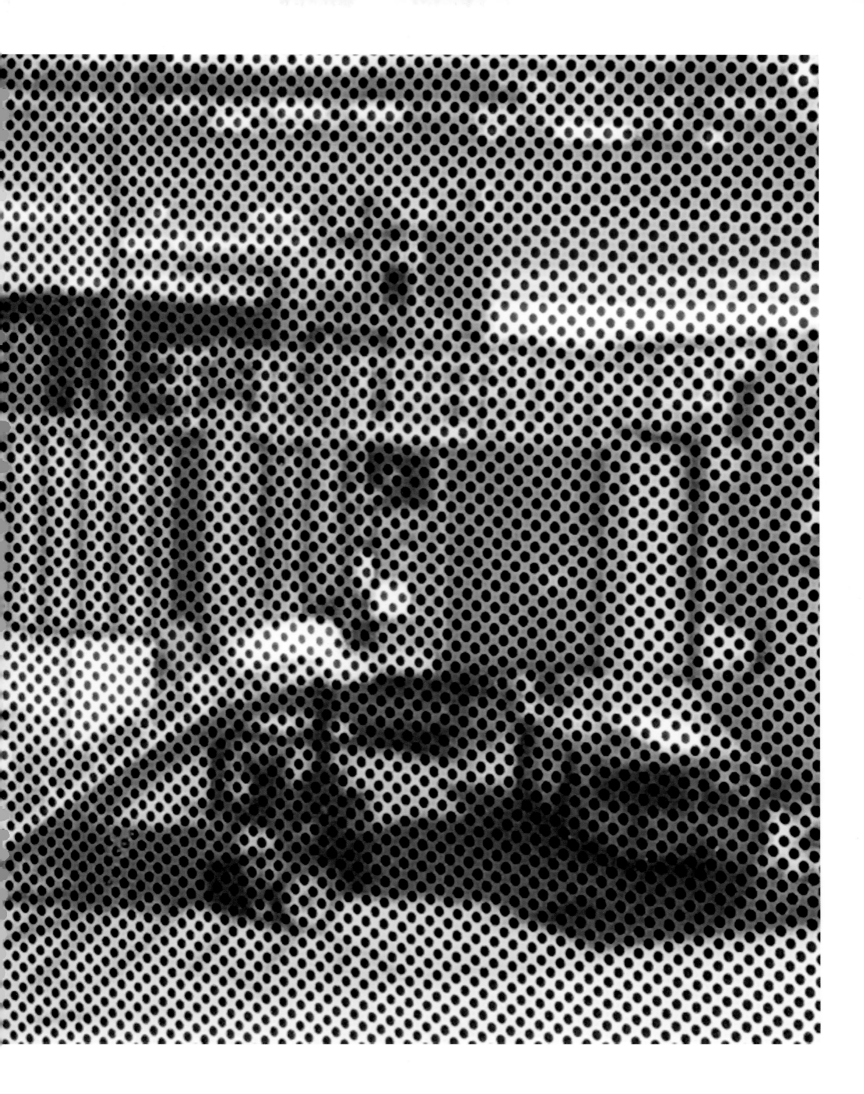

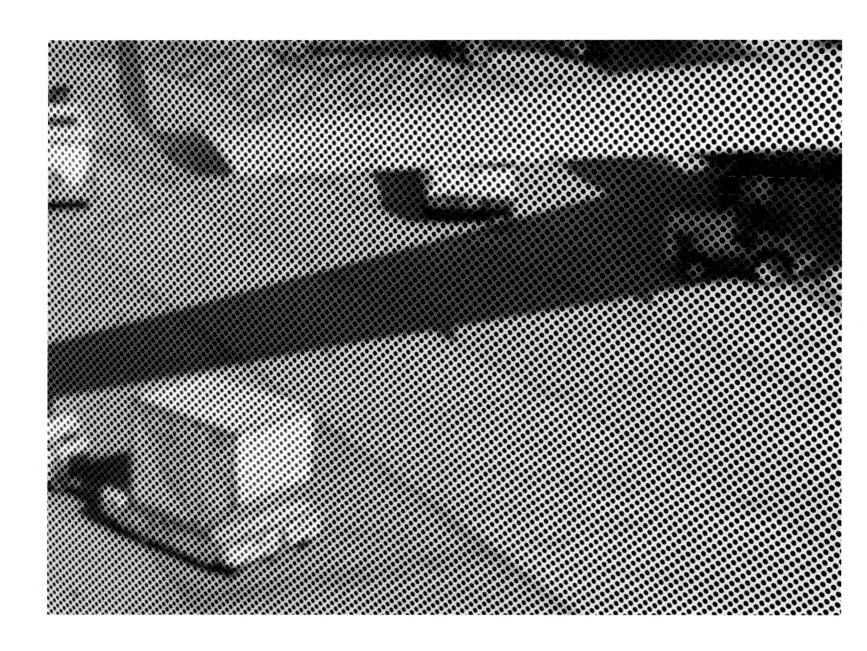

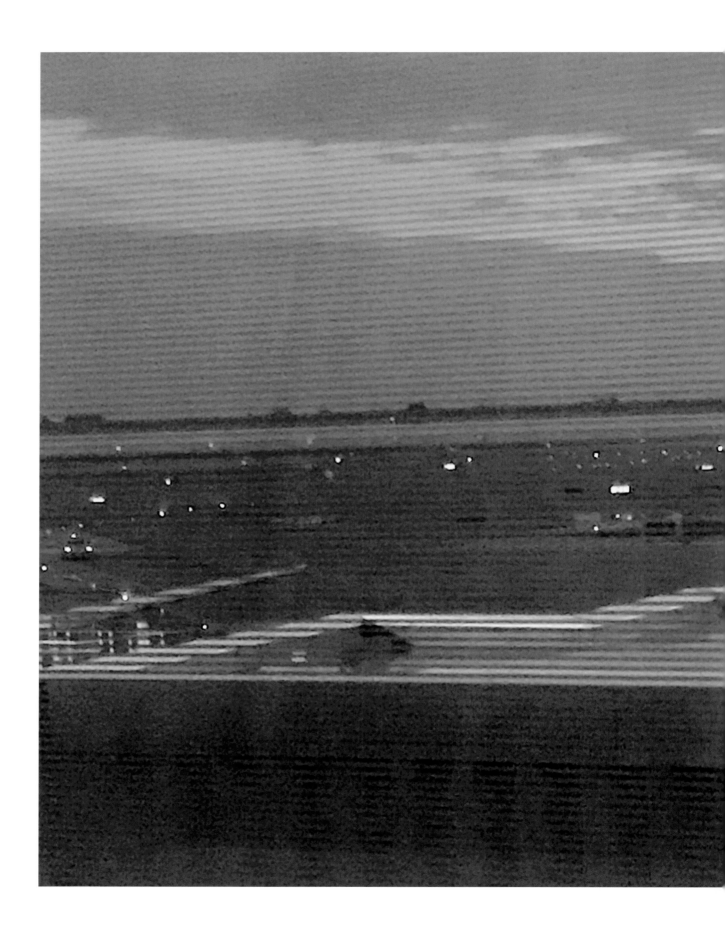

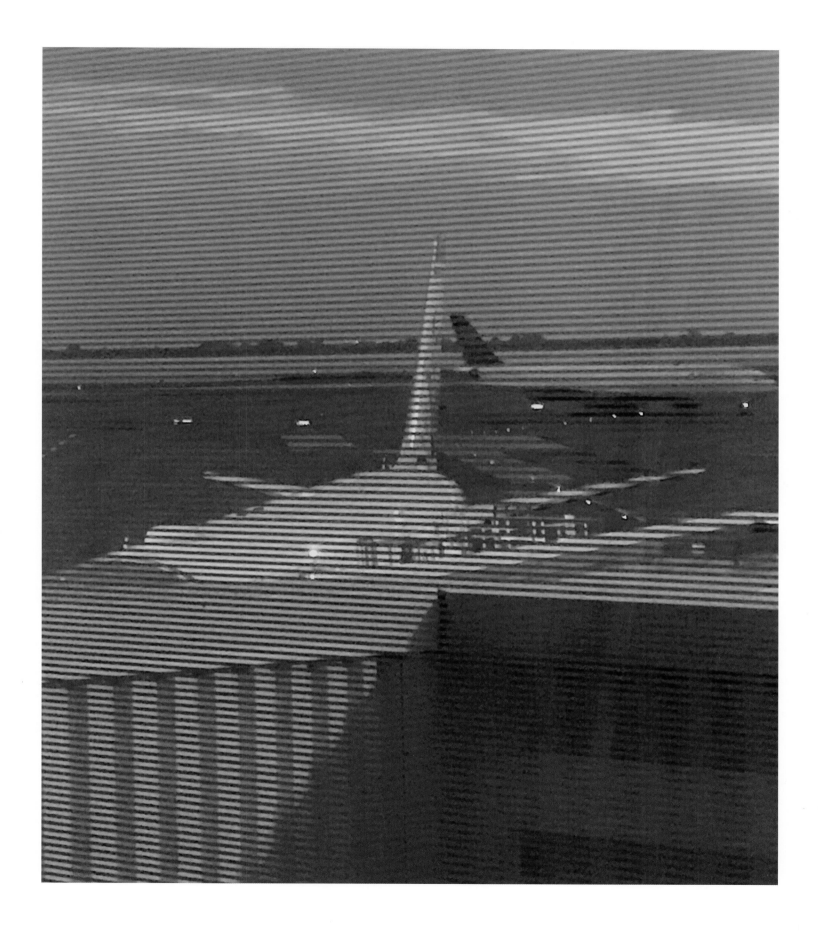

IMGP2984.jpg

JPEG image - 196 KB
Created Yesterday 18:16
Modified Yesterday 18:16
Last opened Yesterday 18:16
Dimensions 2000 × 1500
Add Tags...

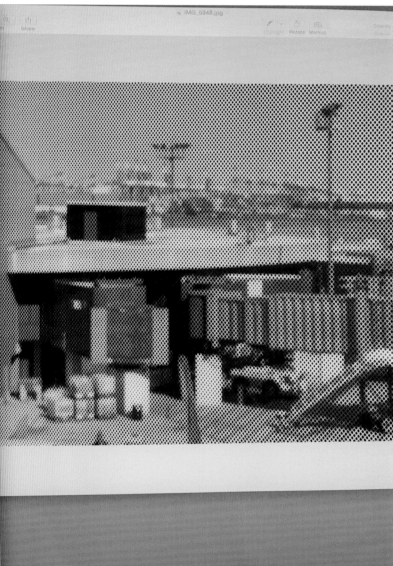

IMGP3144.jpg

JPEG image - 143 KB
Created Yesterday 18:31
Modified Yesterday 18:31
Last opened Yesterday 18:31
Dimensions 2000 × 1500
Add Tags...

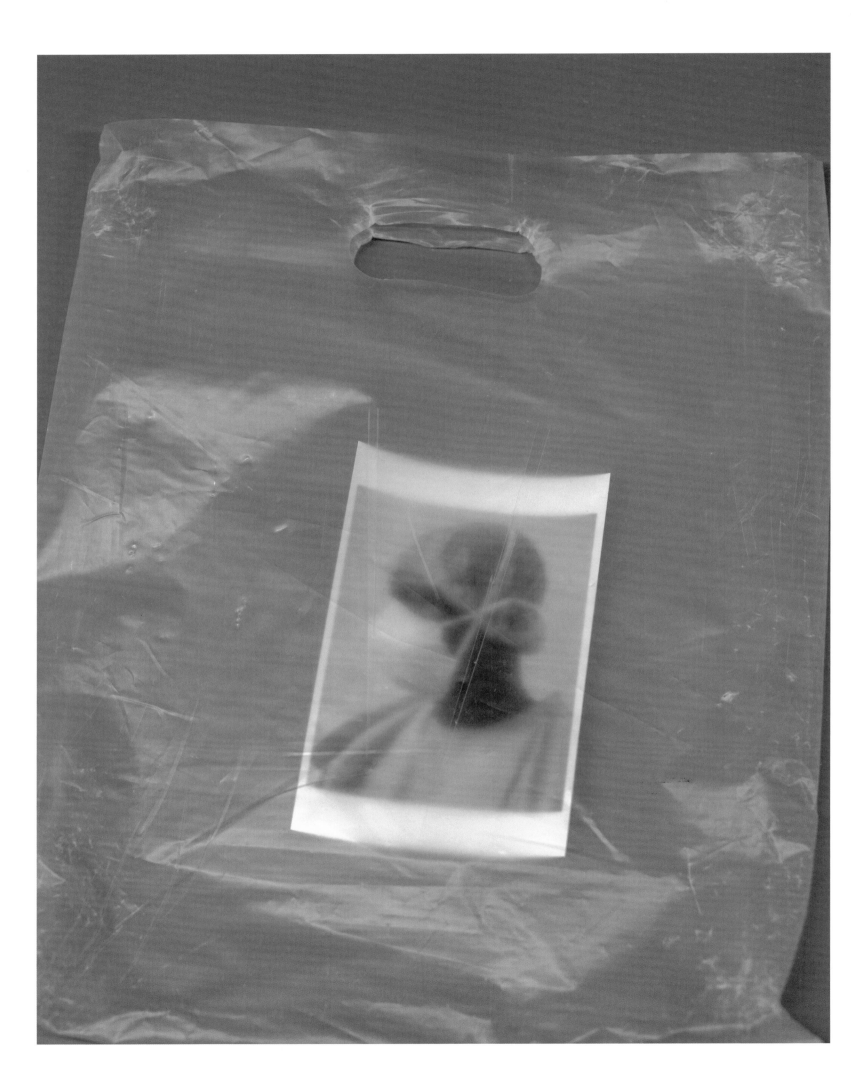

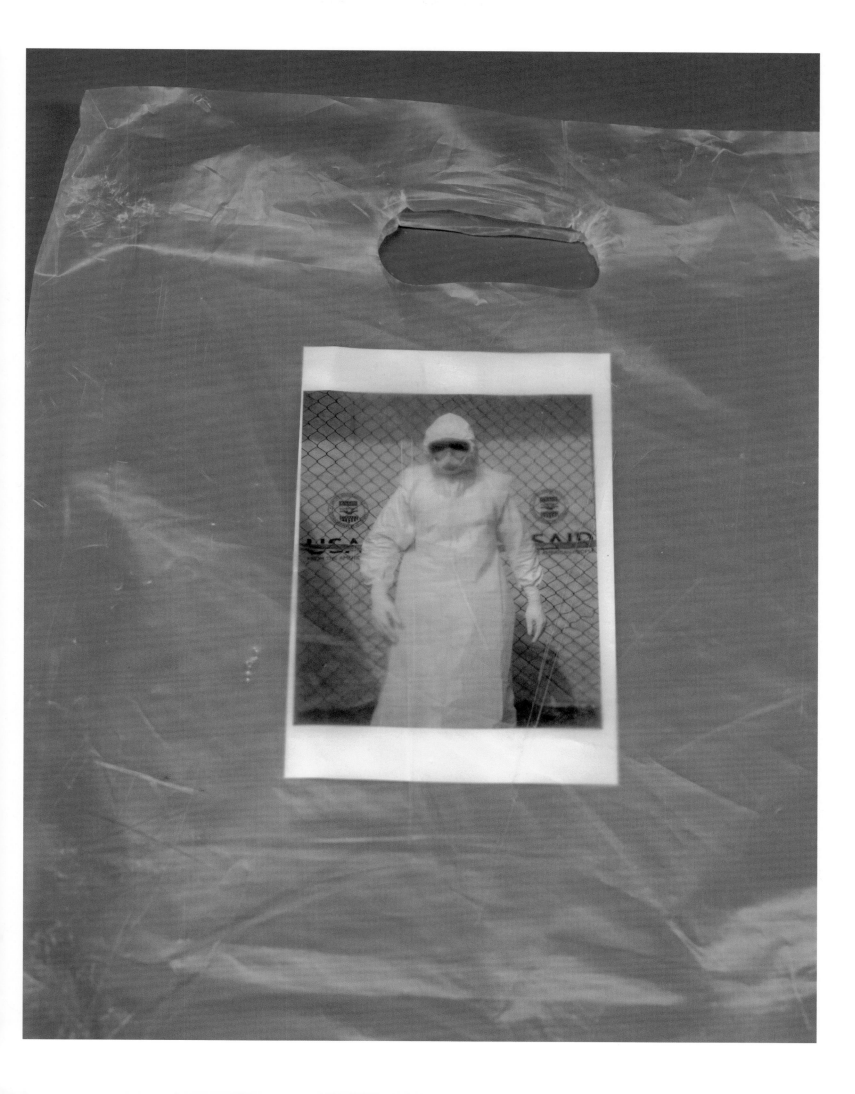

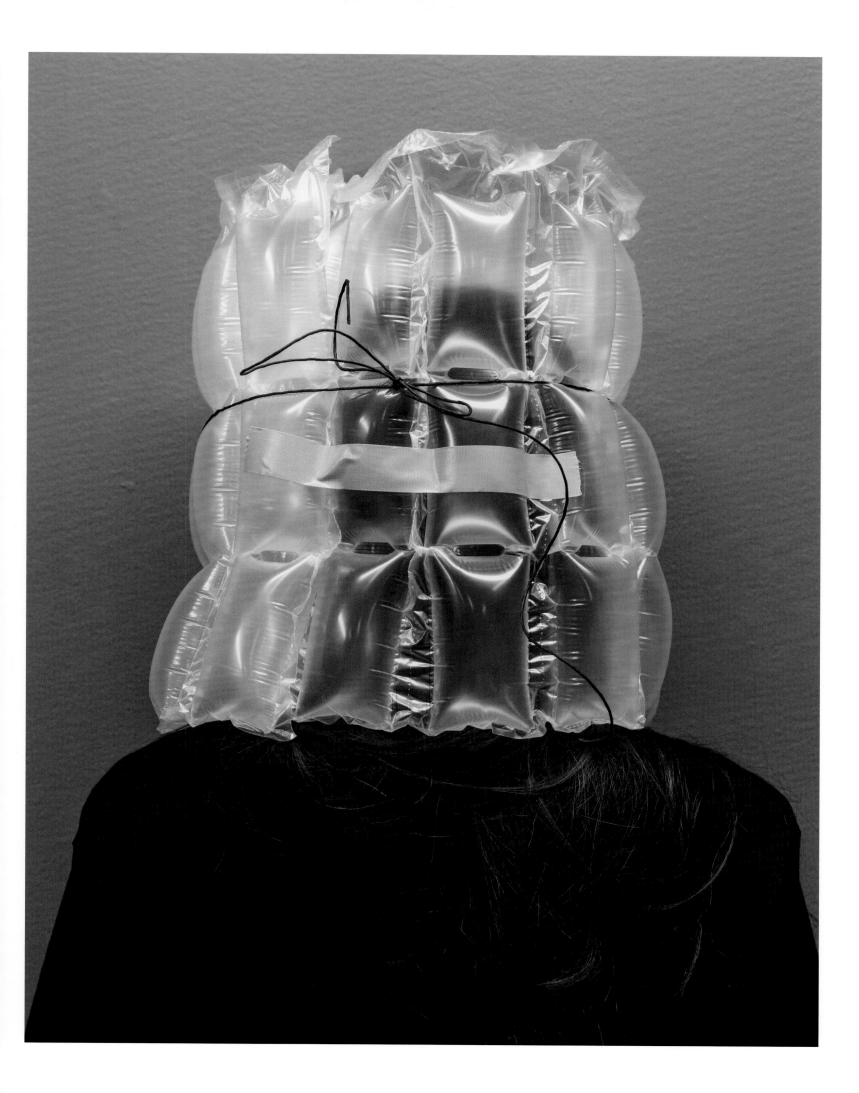

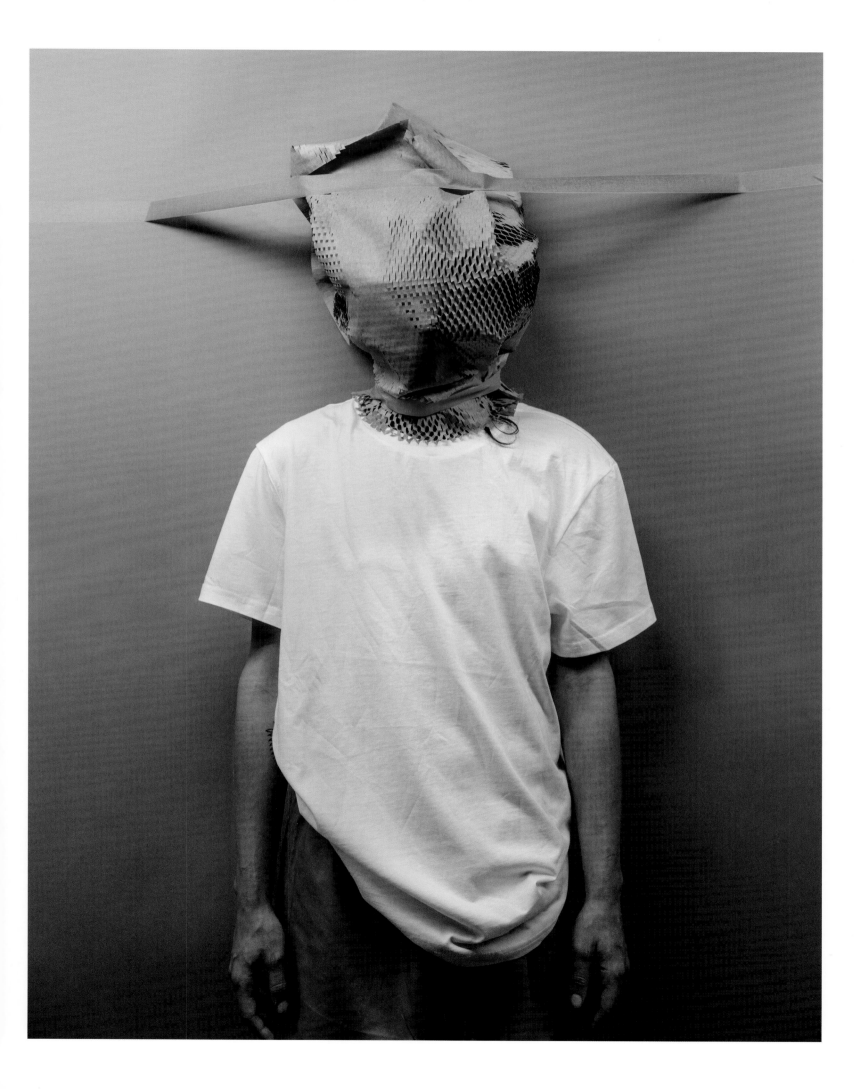

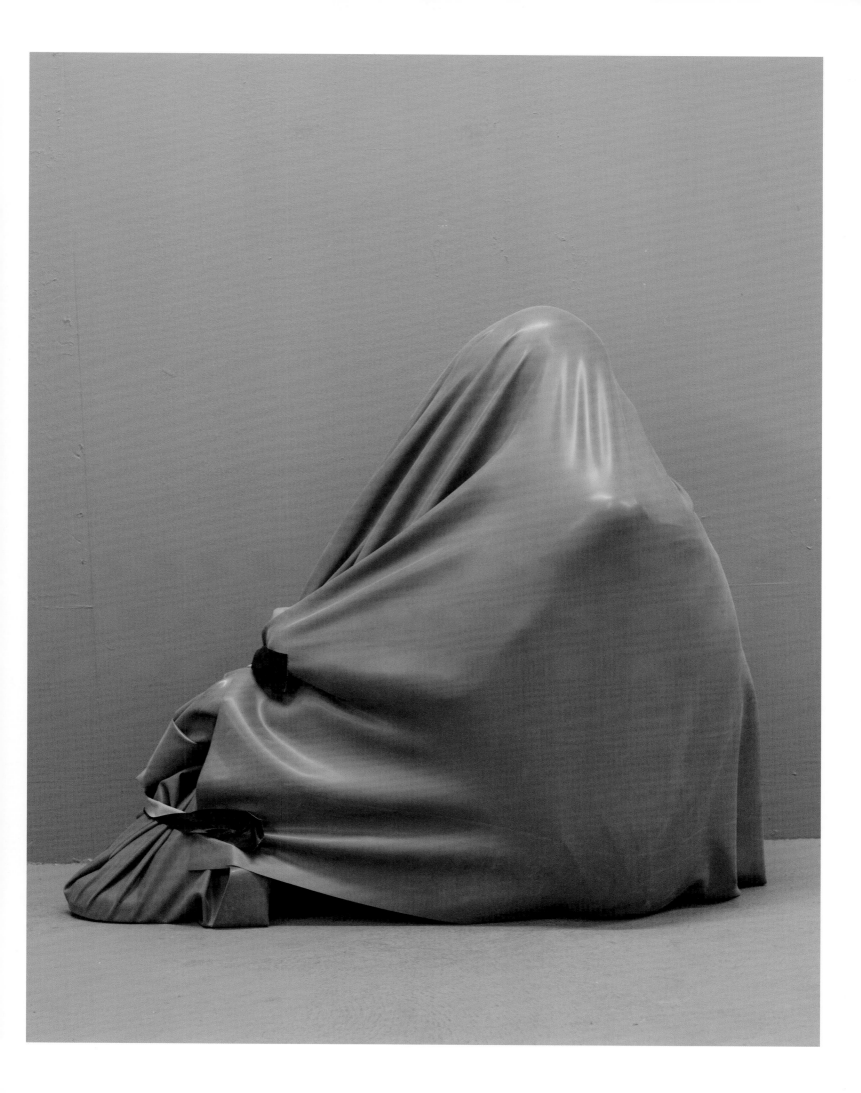

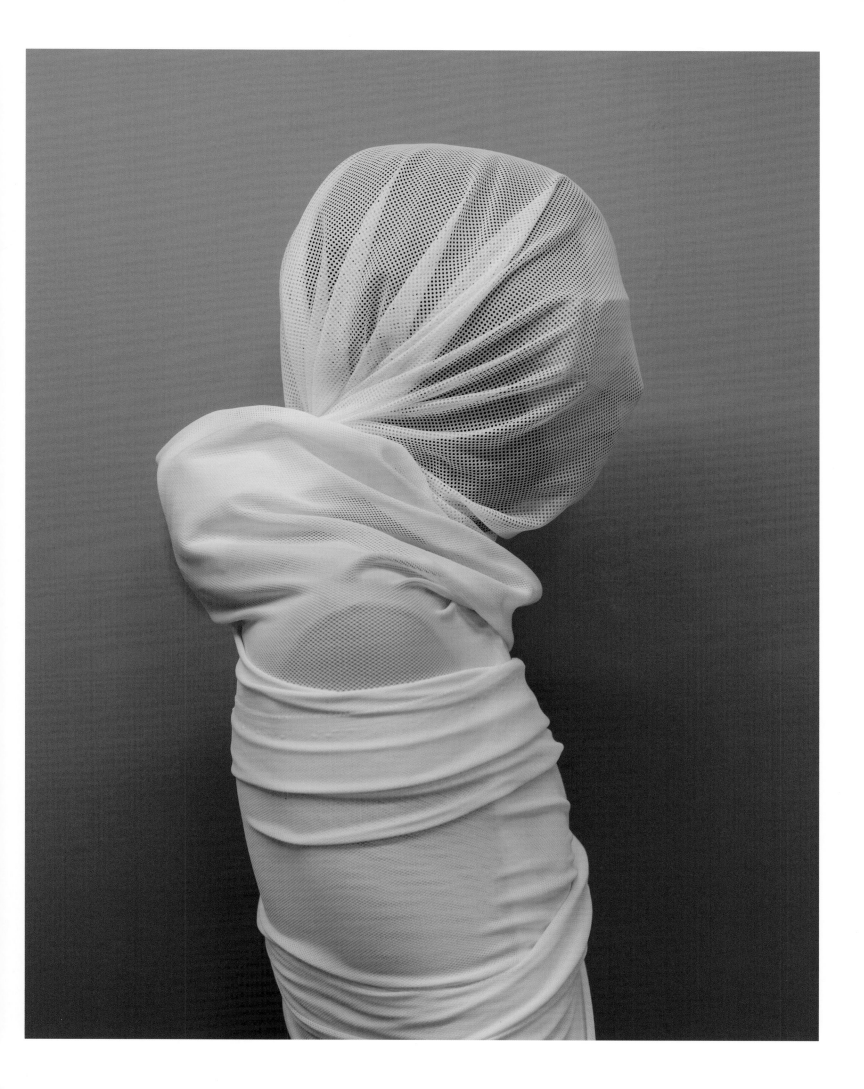

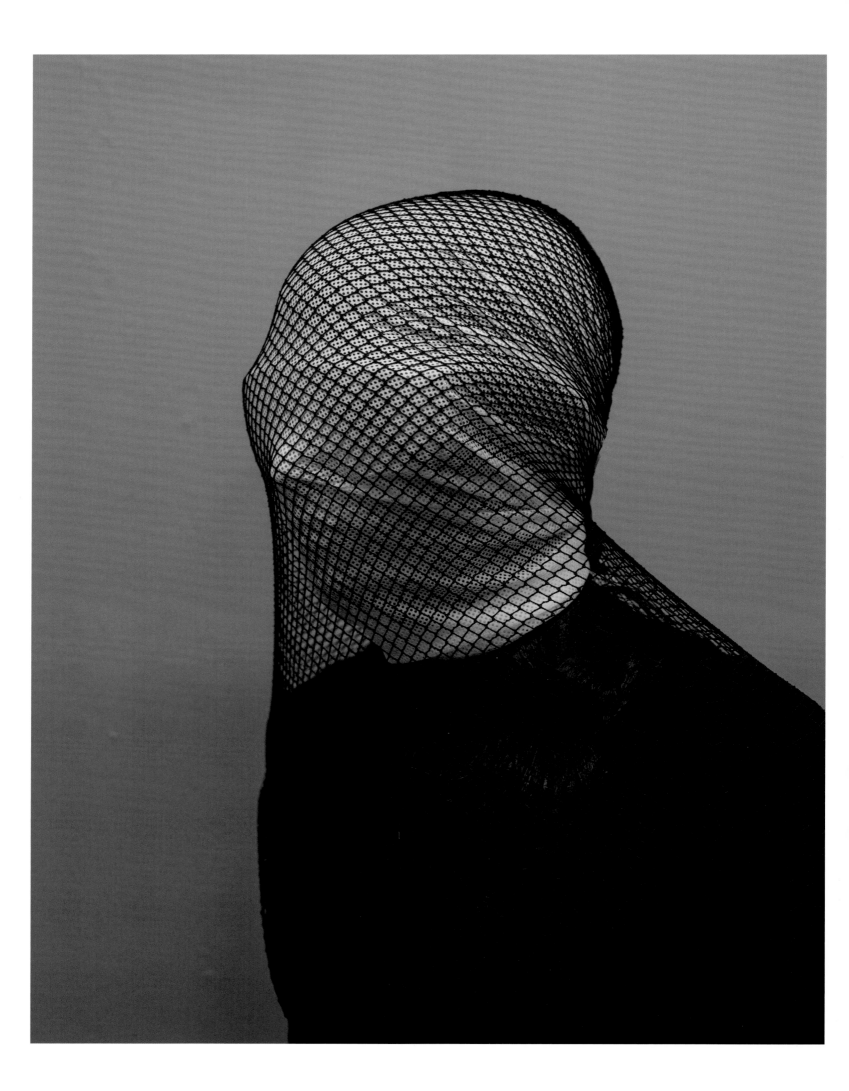

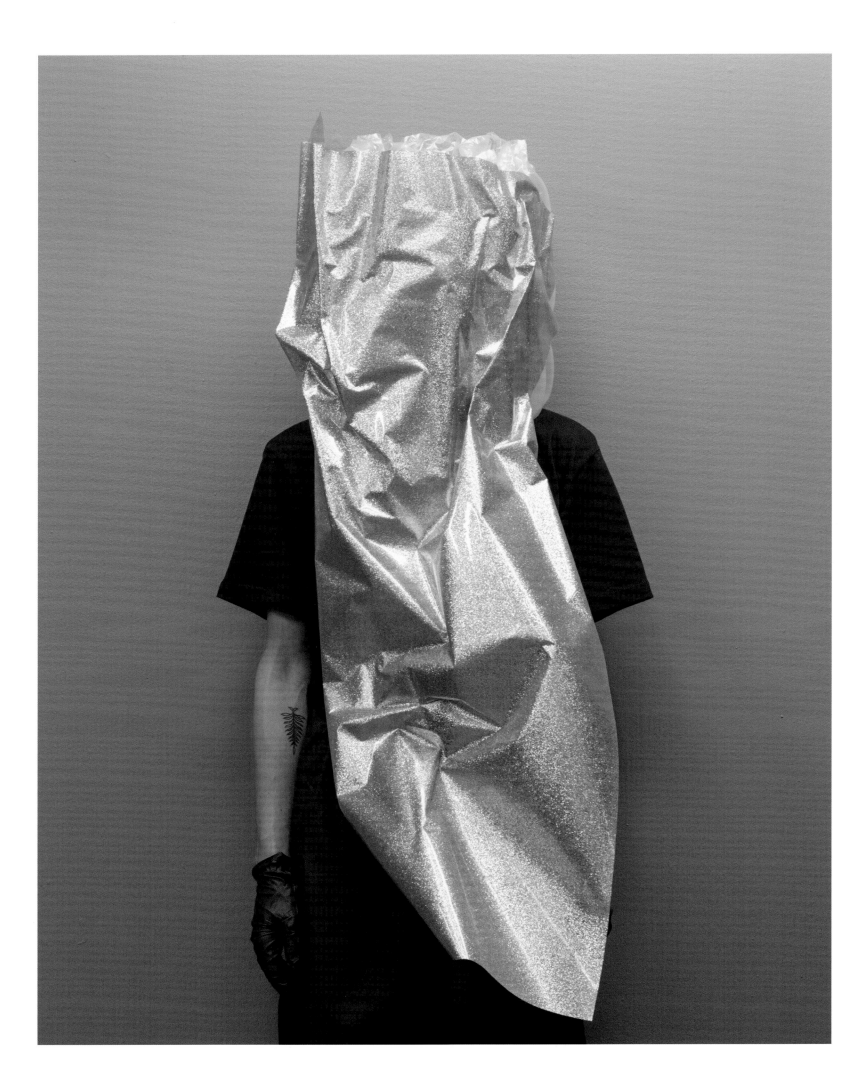

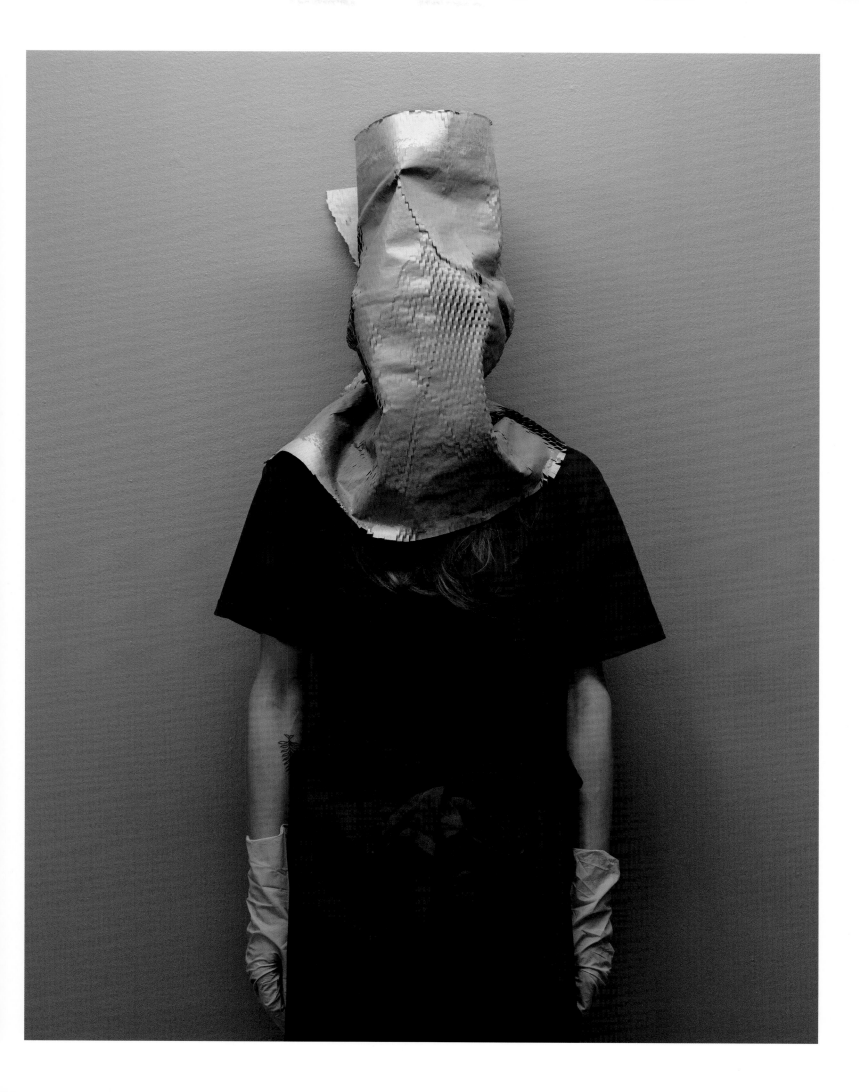

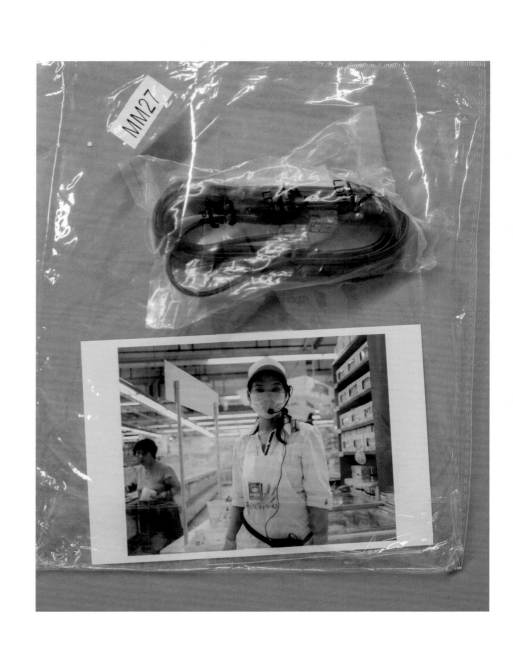

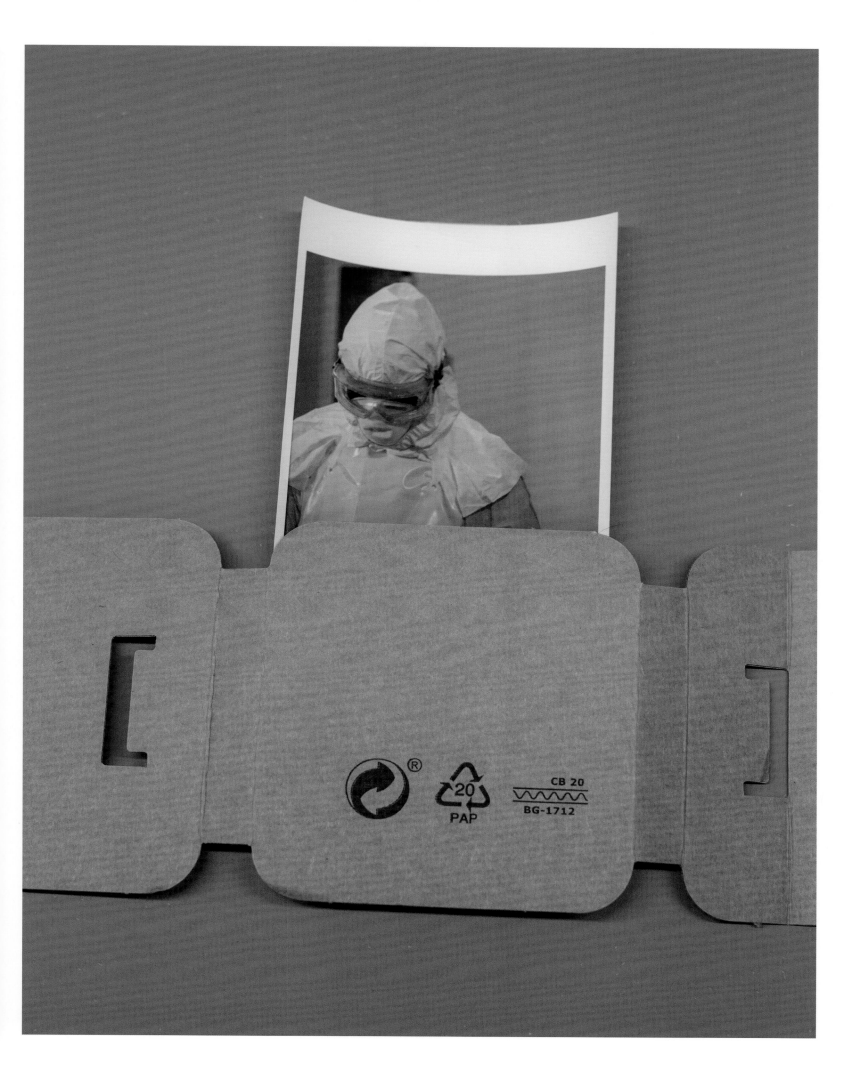

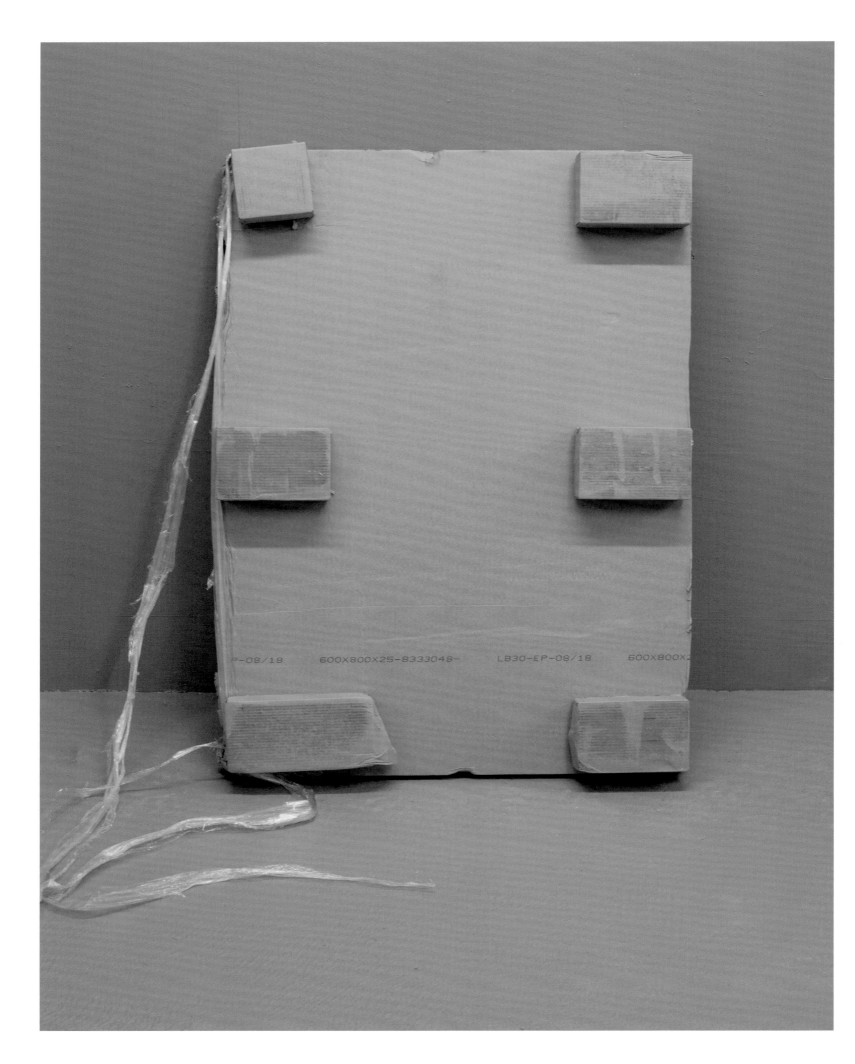

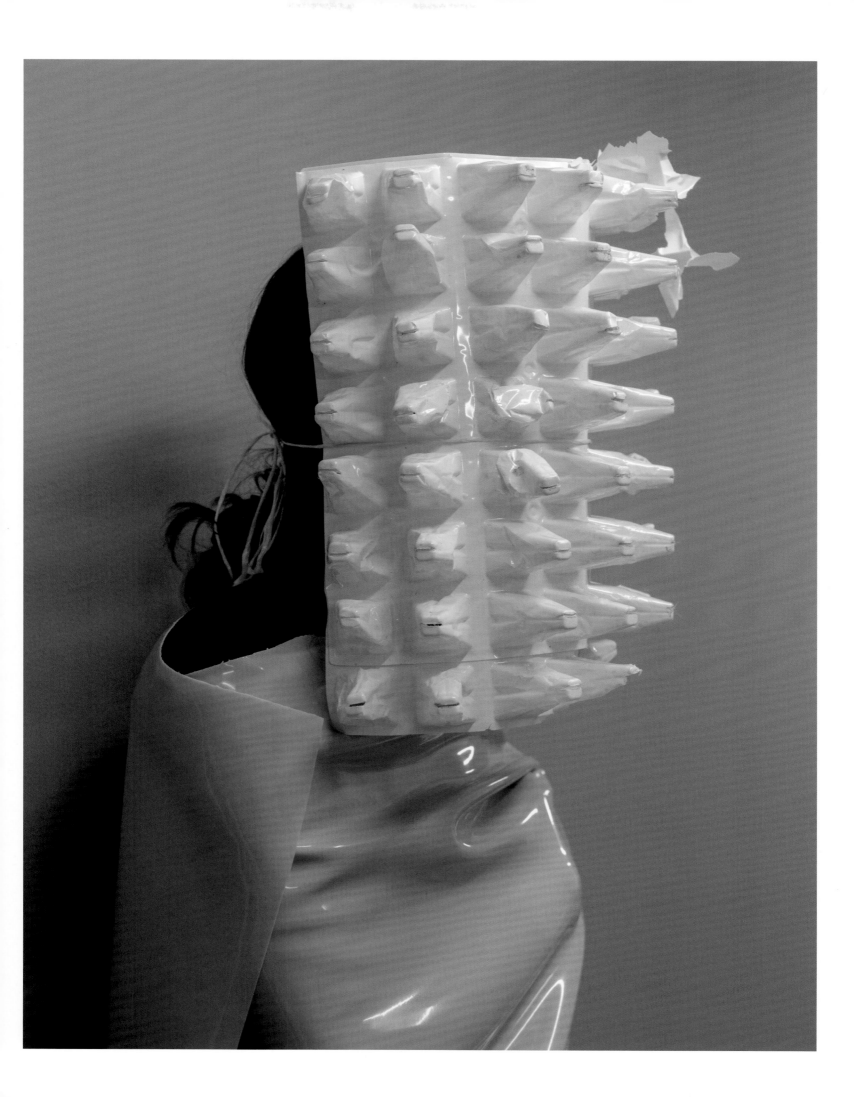

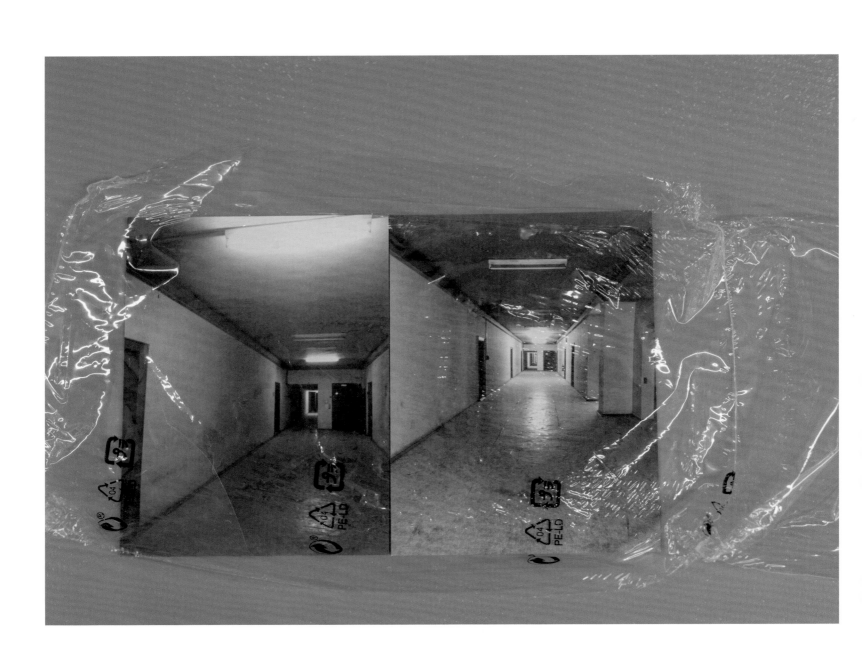

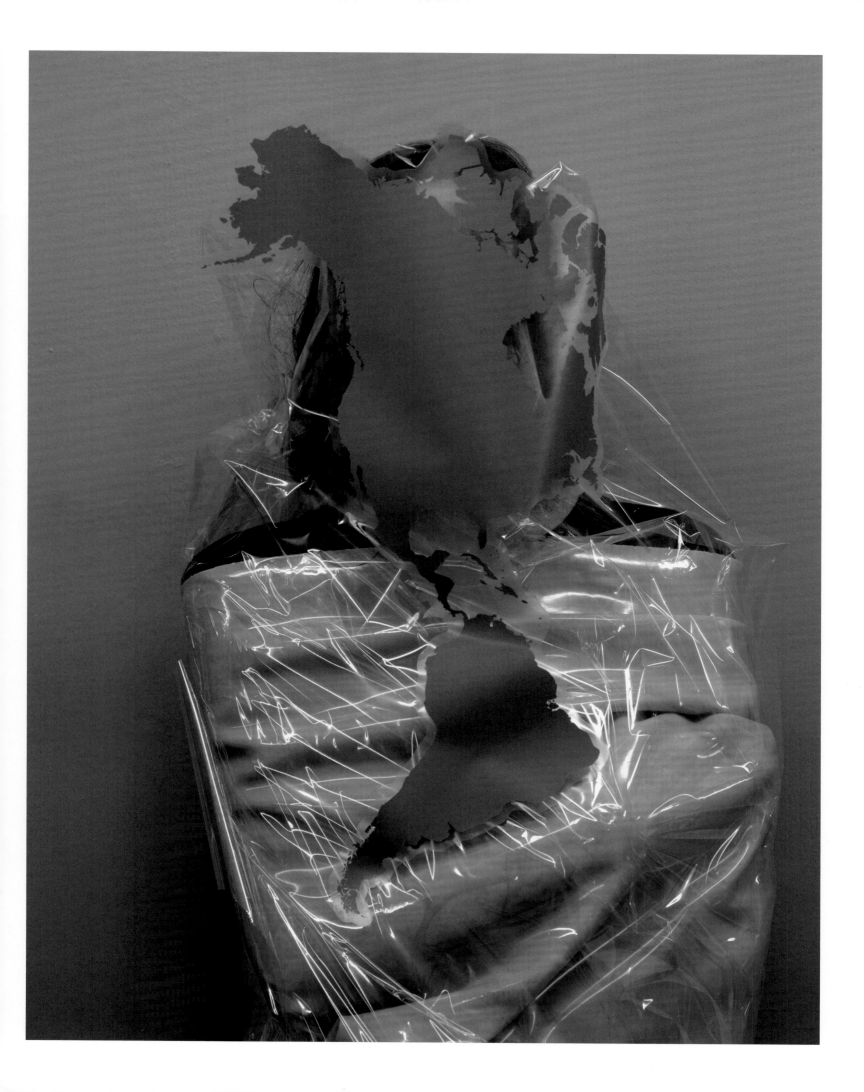

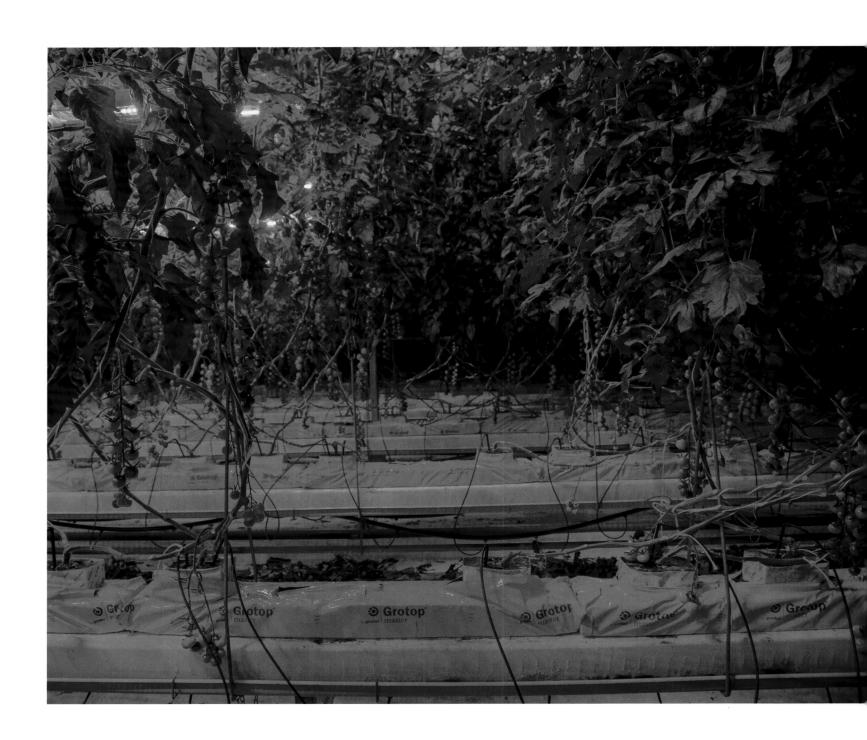

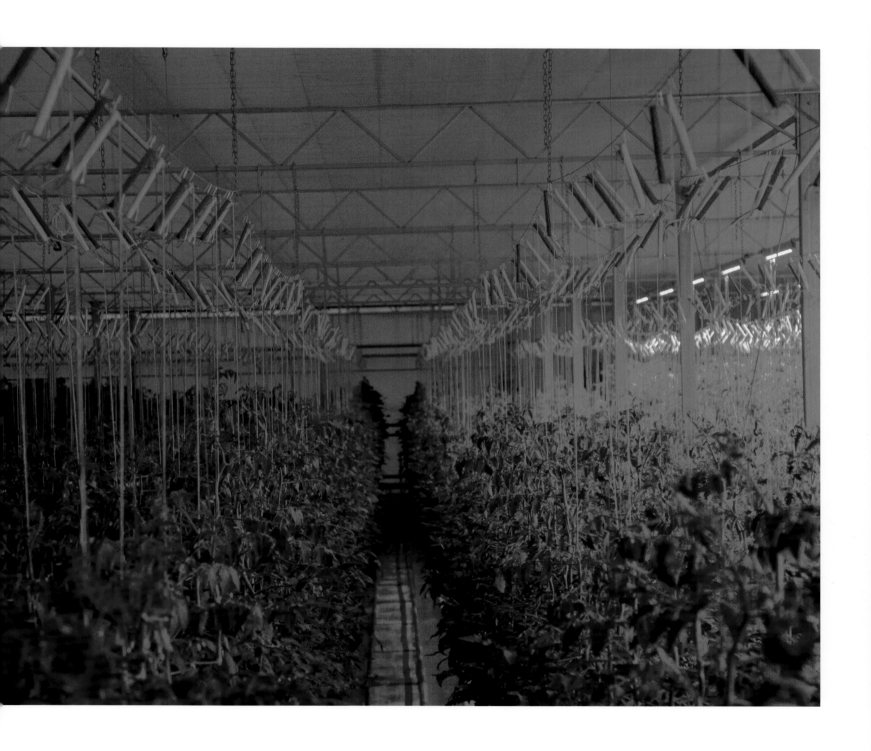

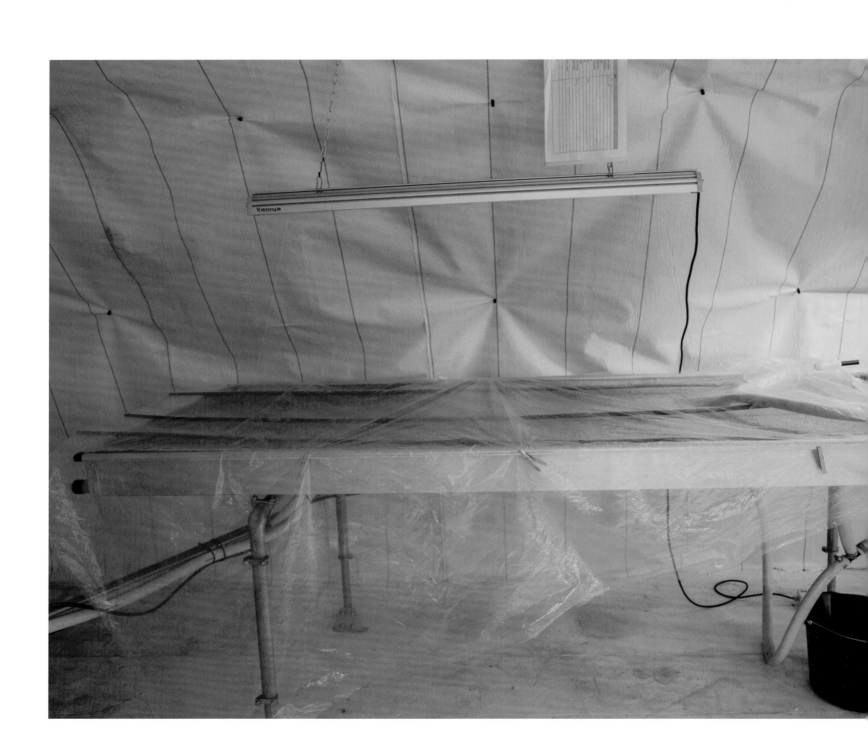

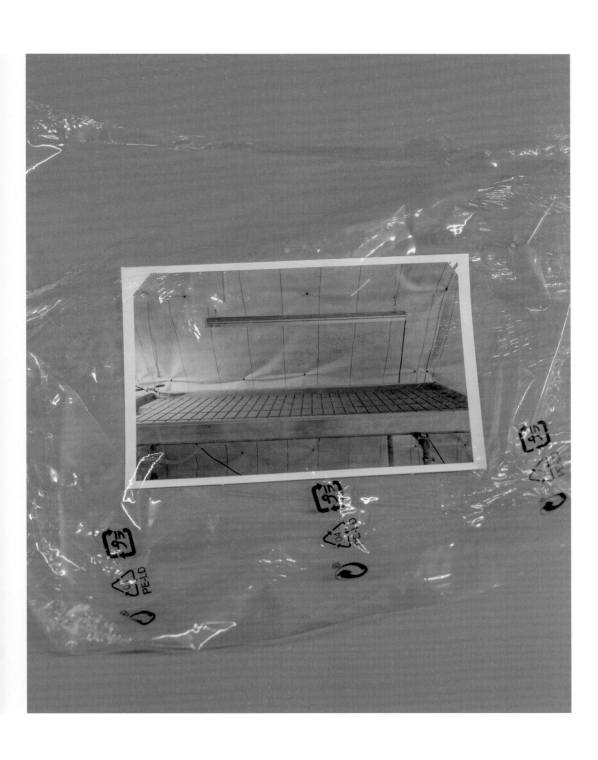

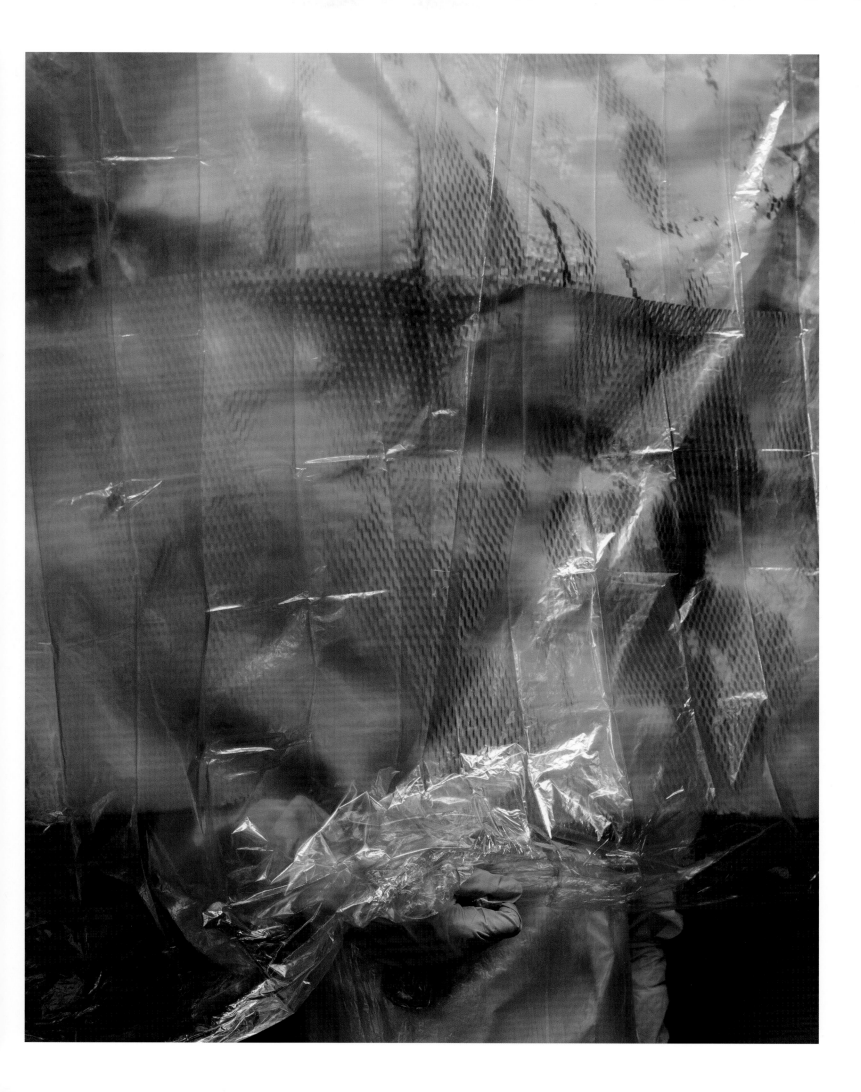

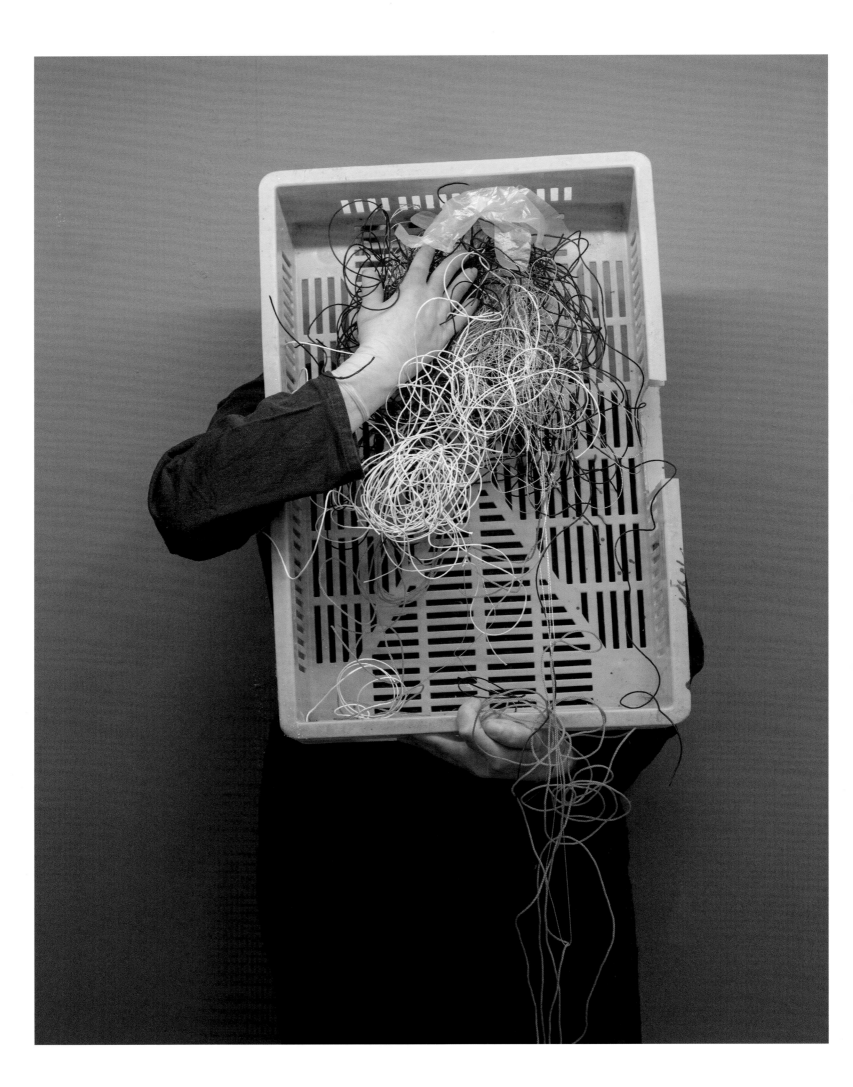

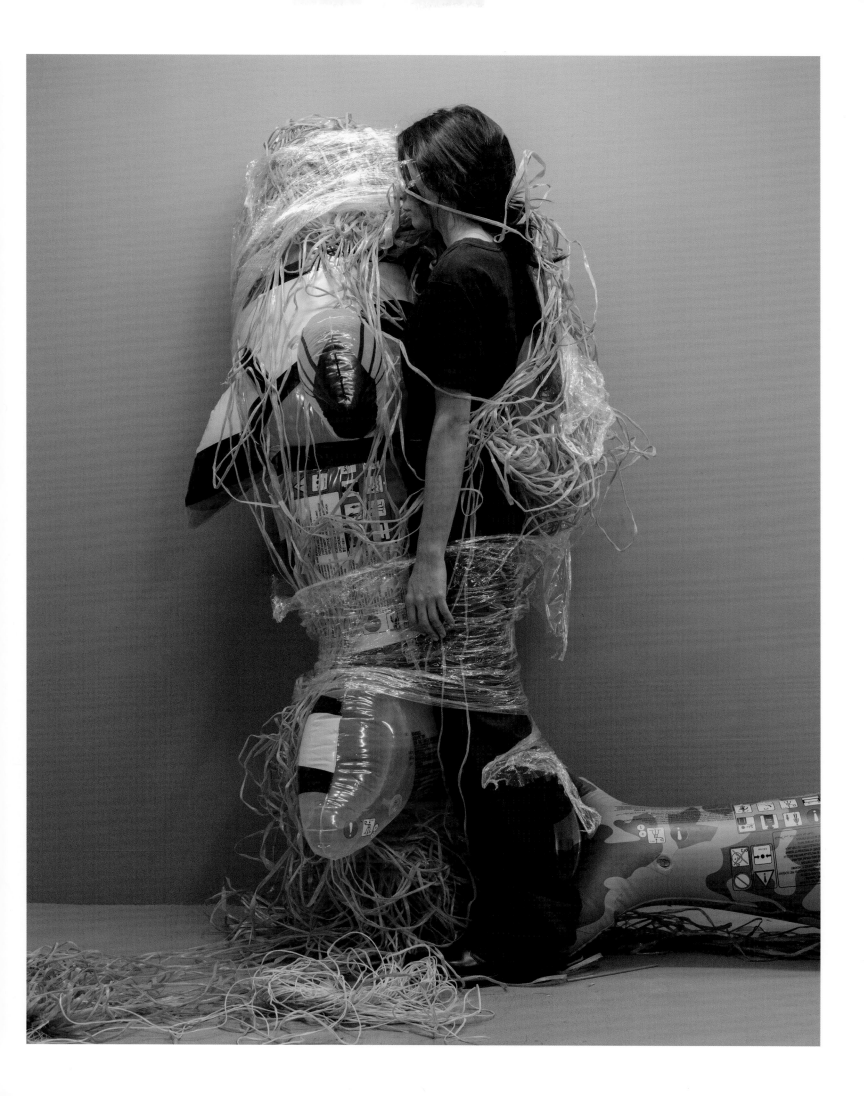

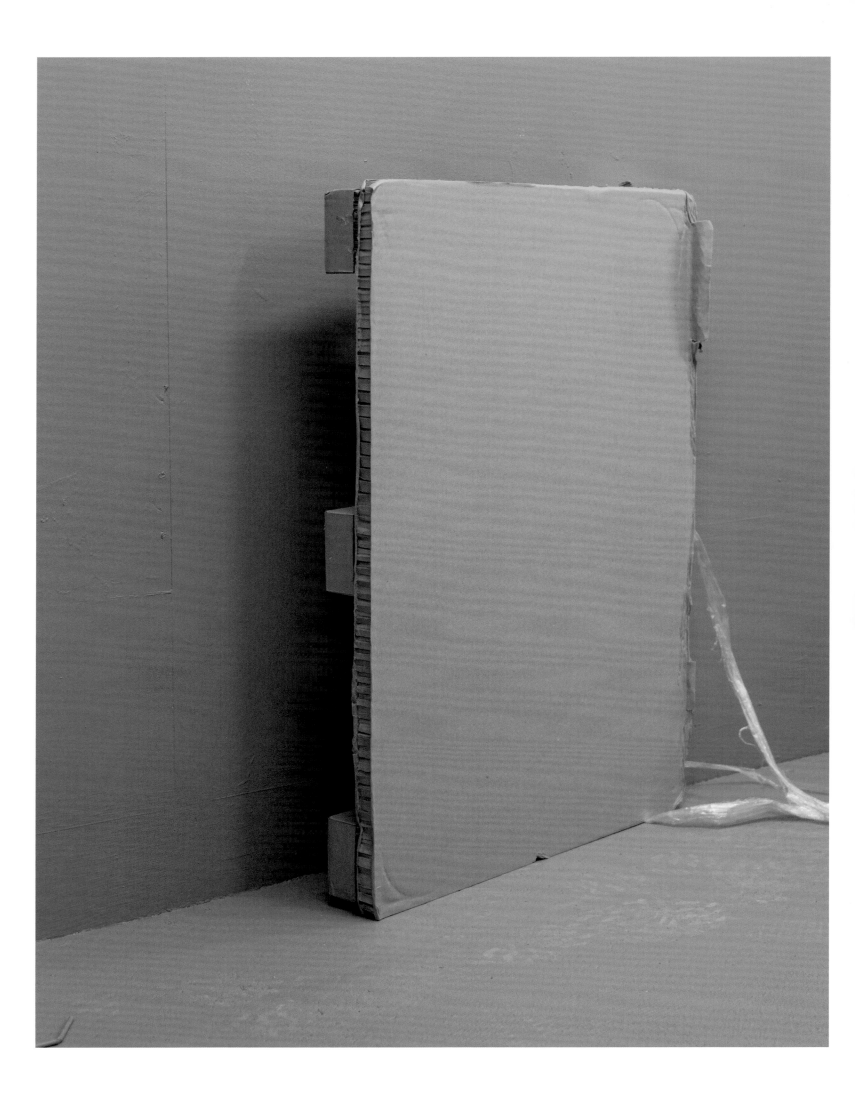

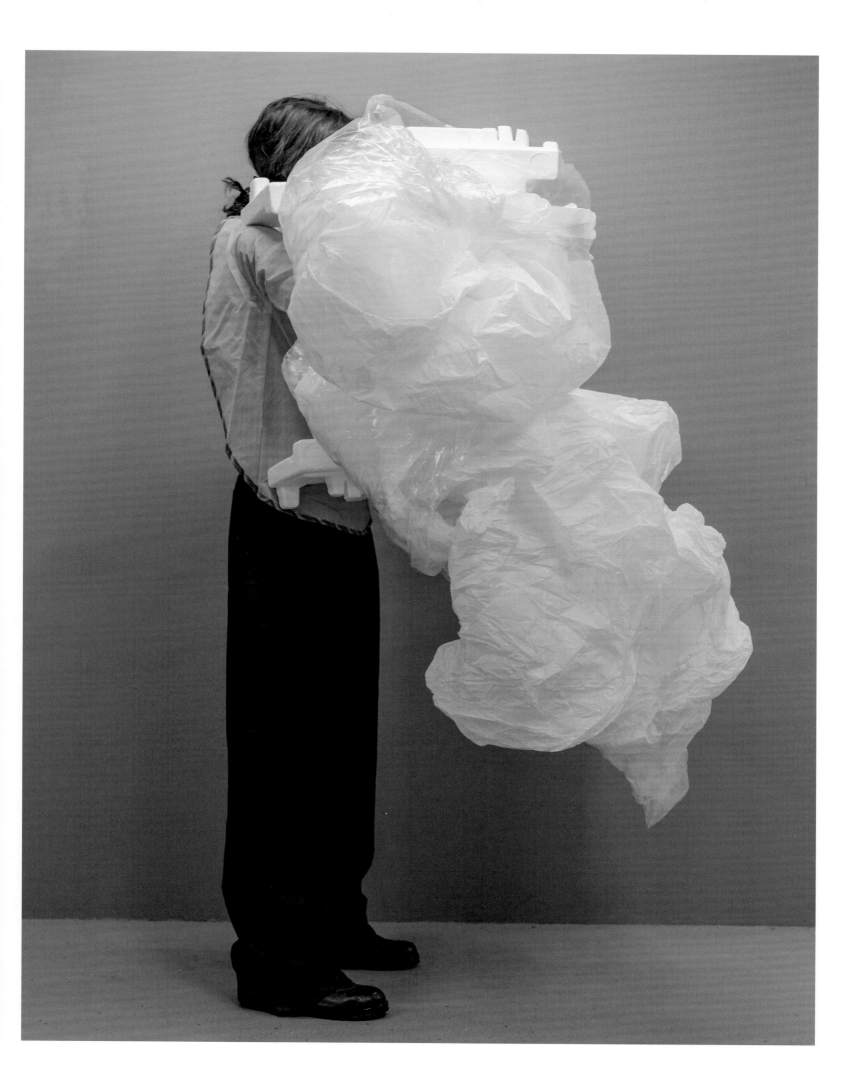

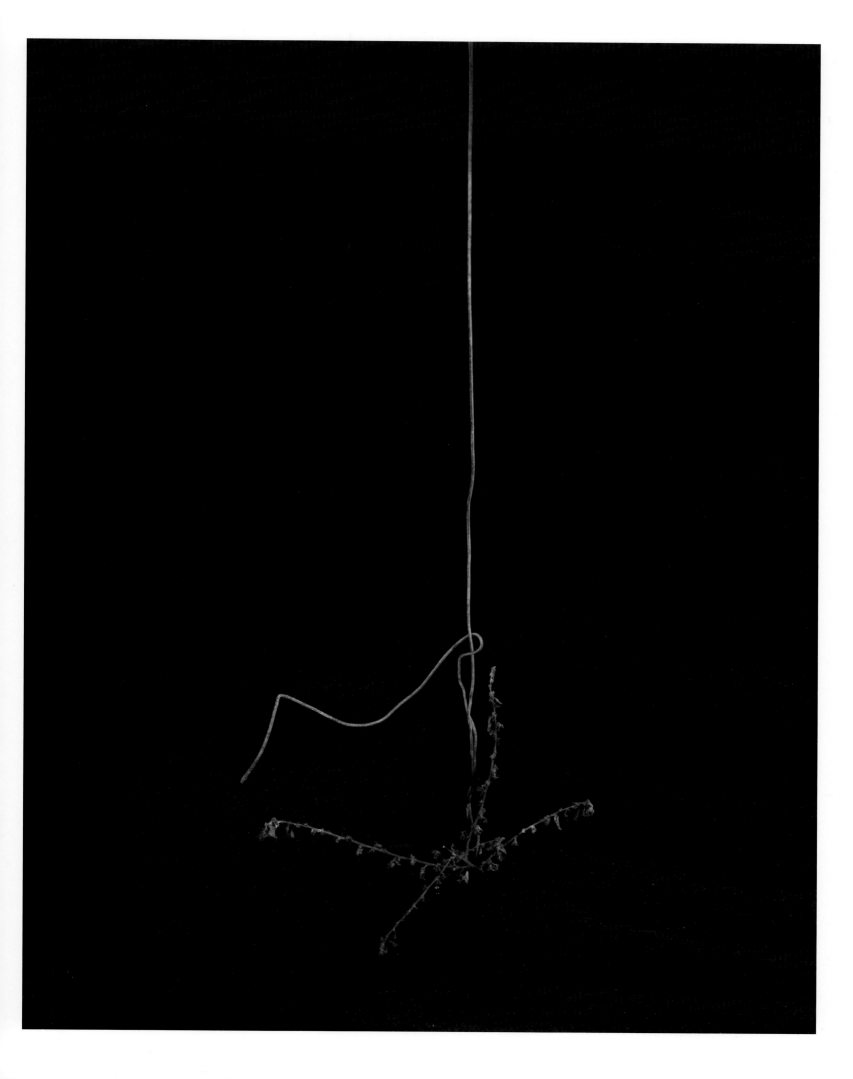

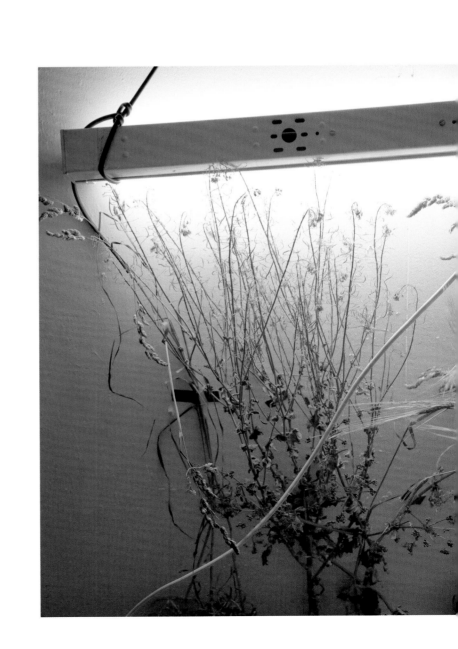

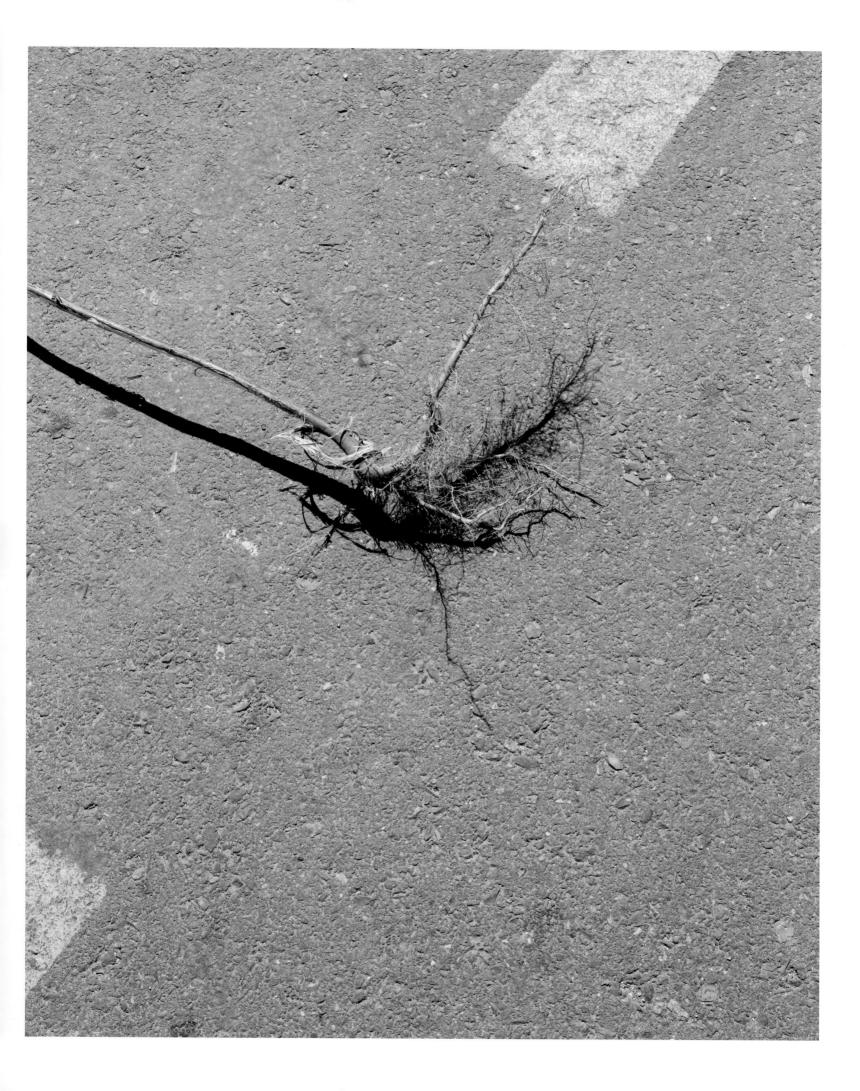

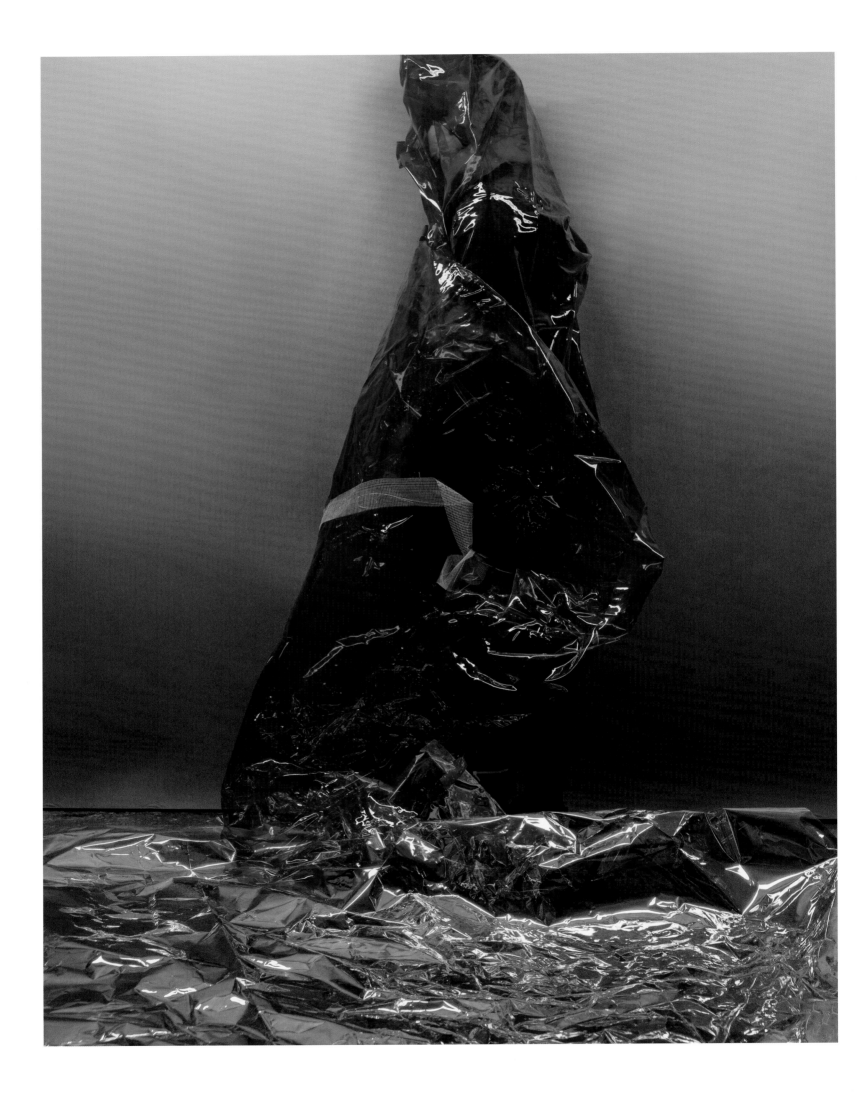

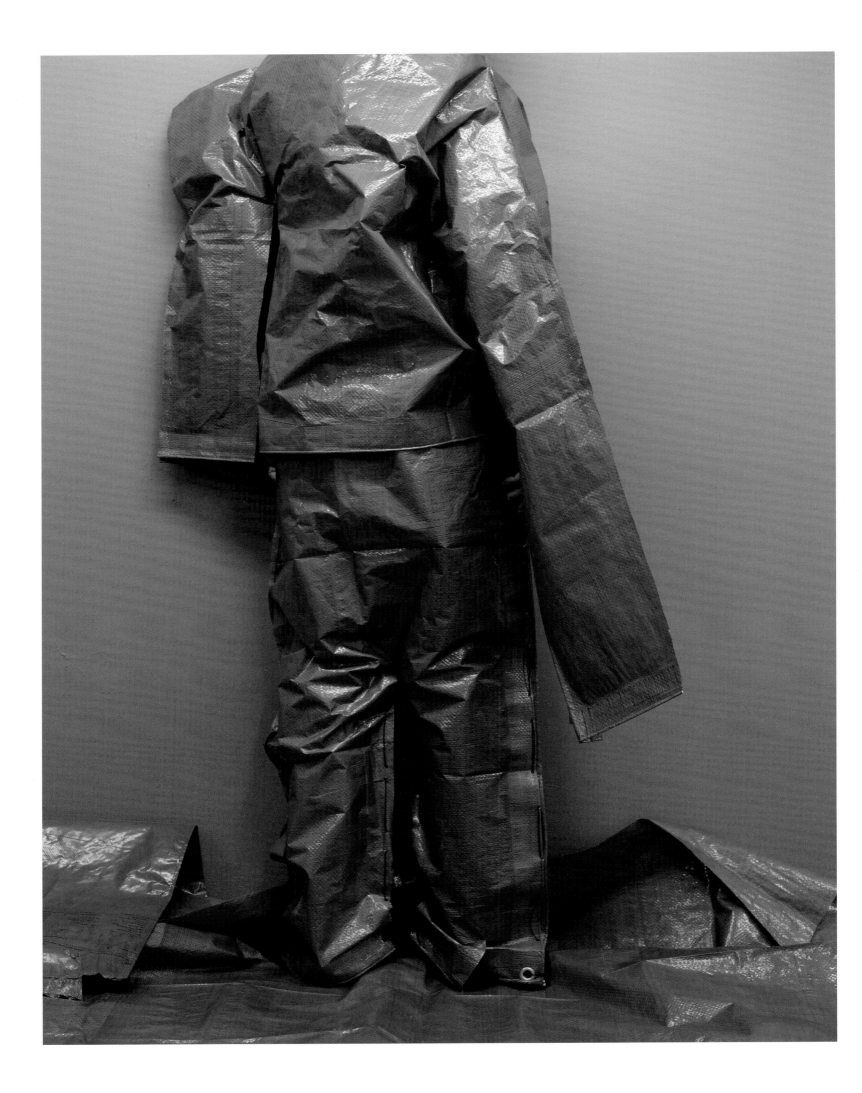

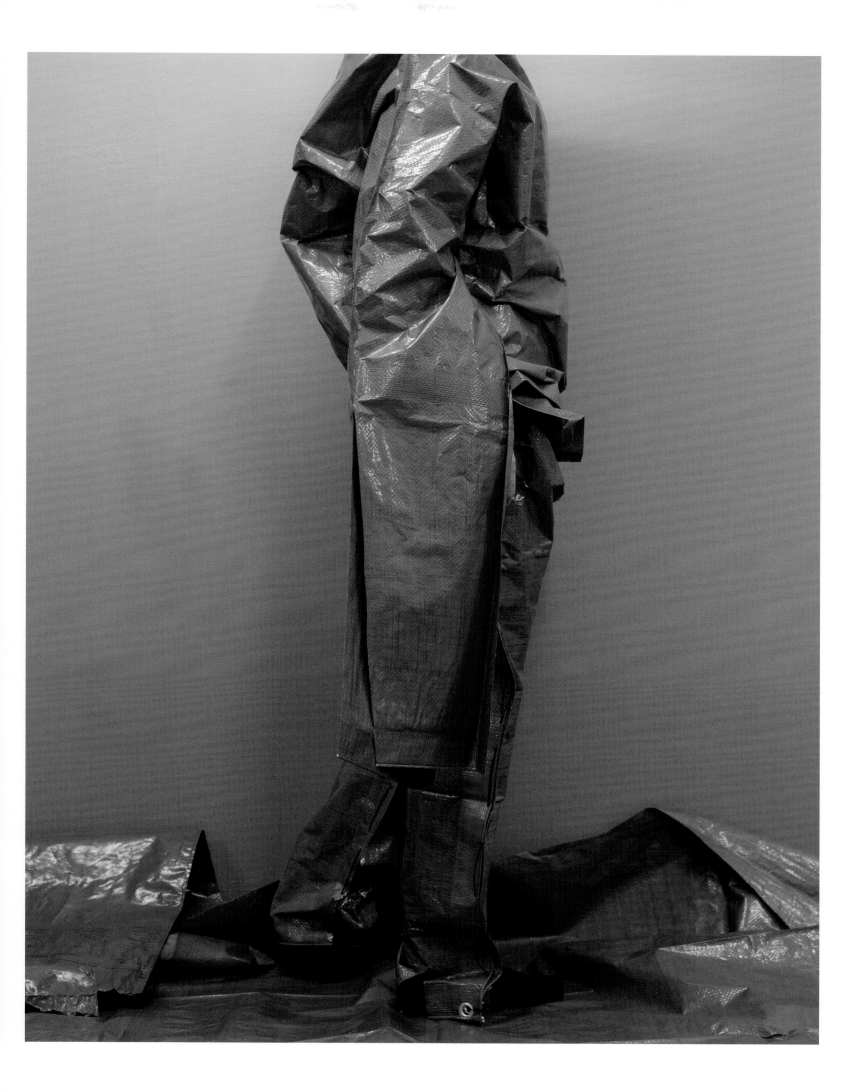

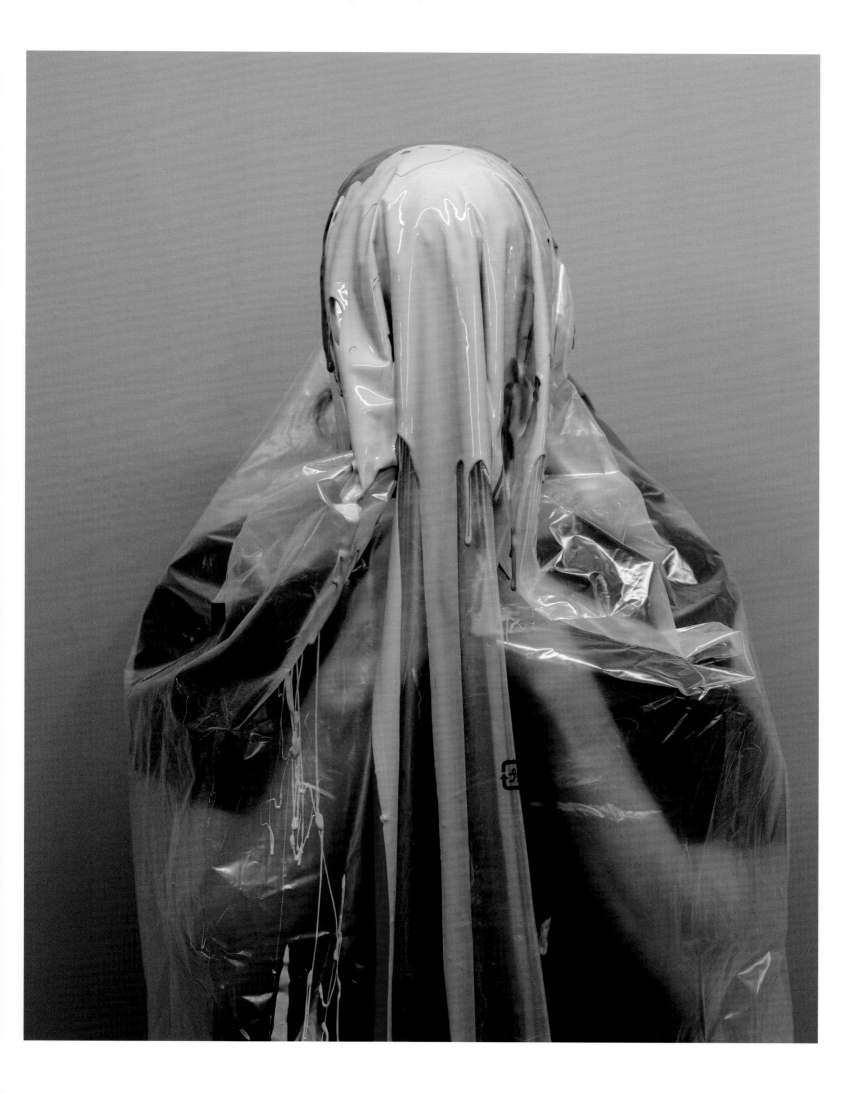

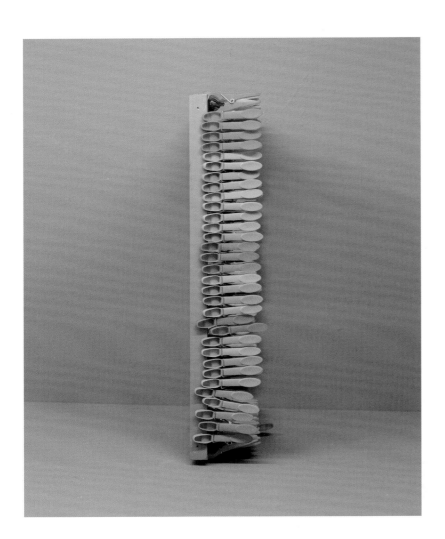

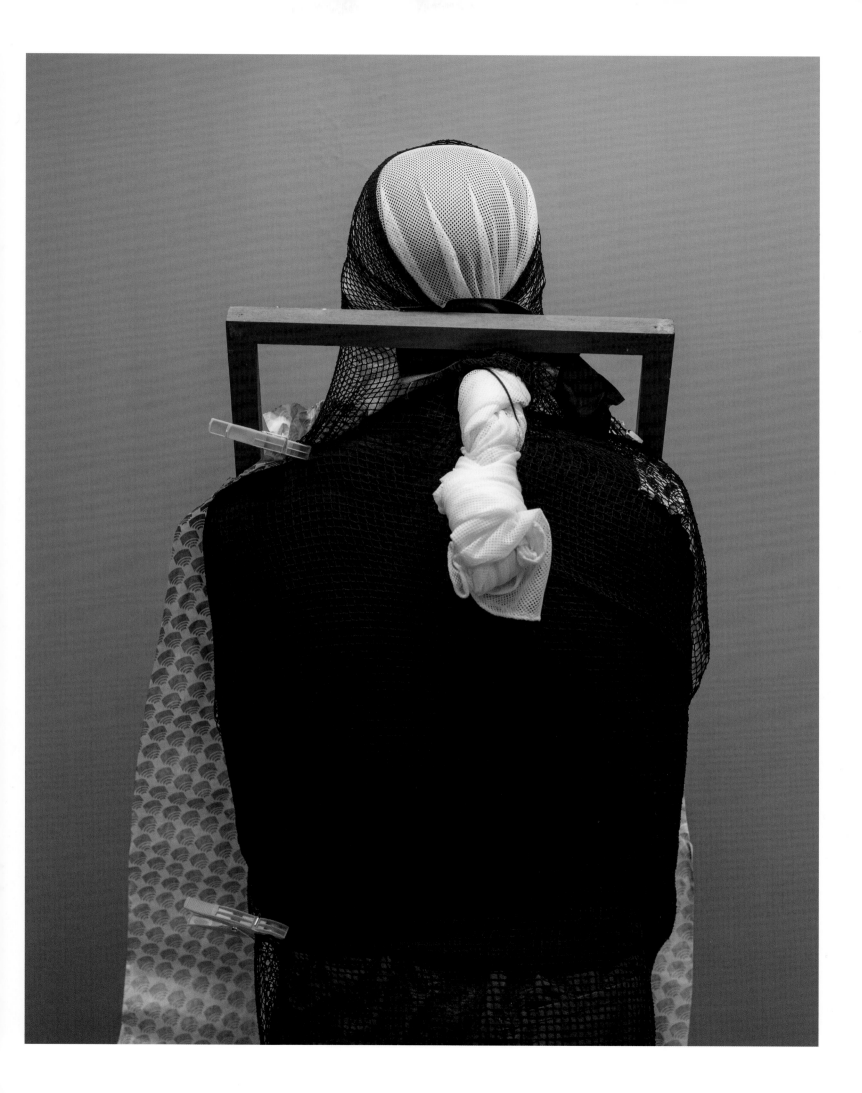

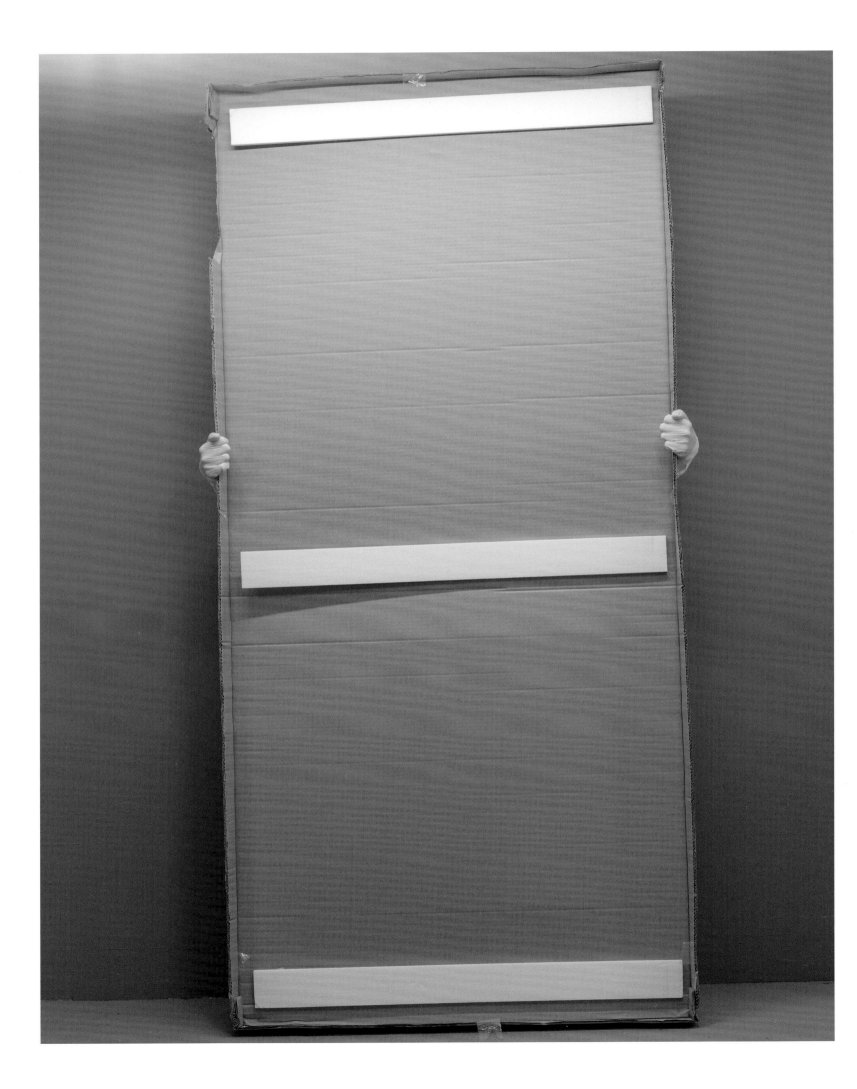

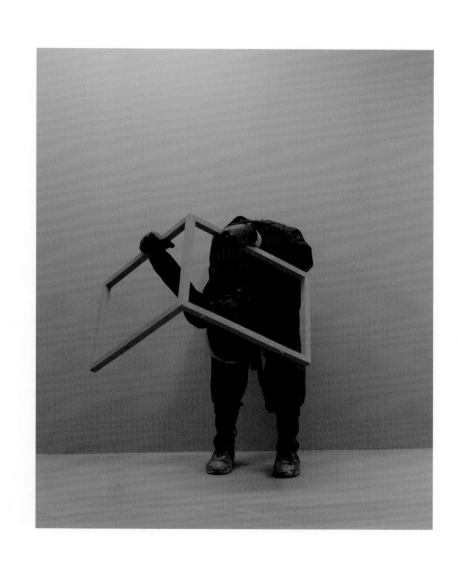

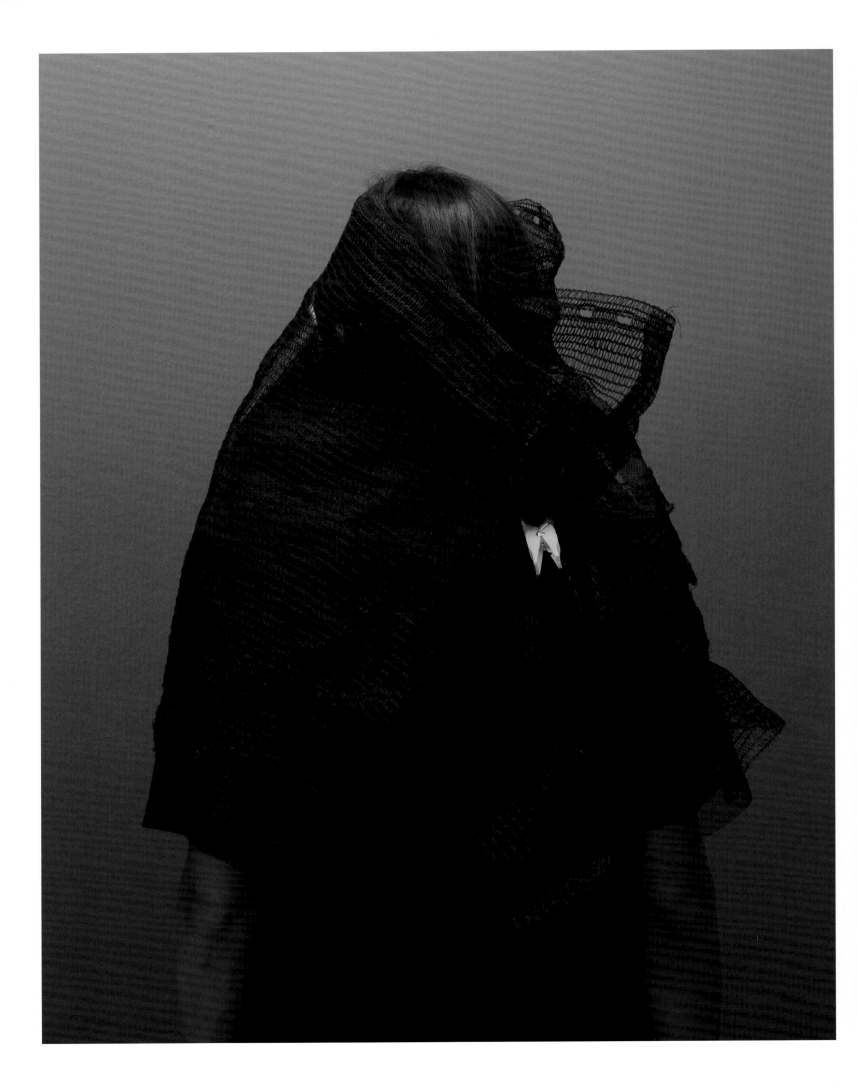

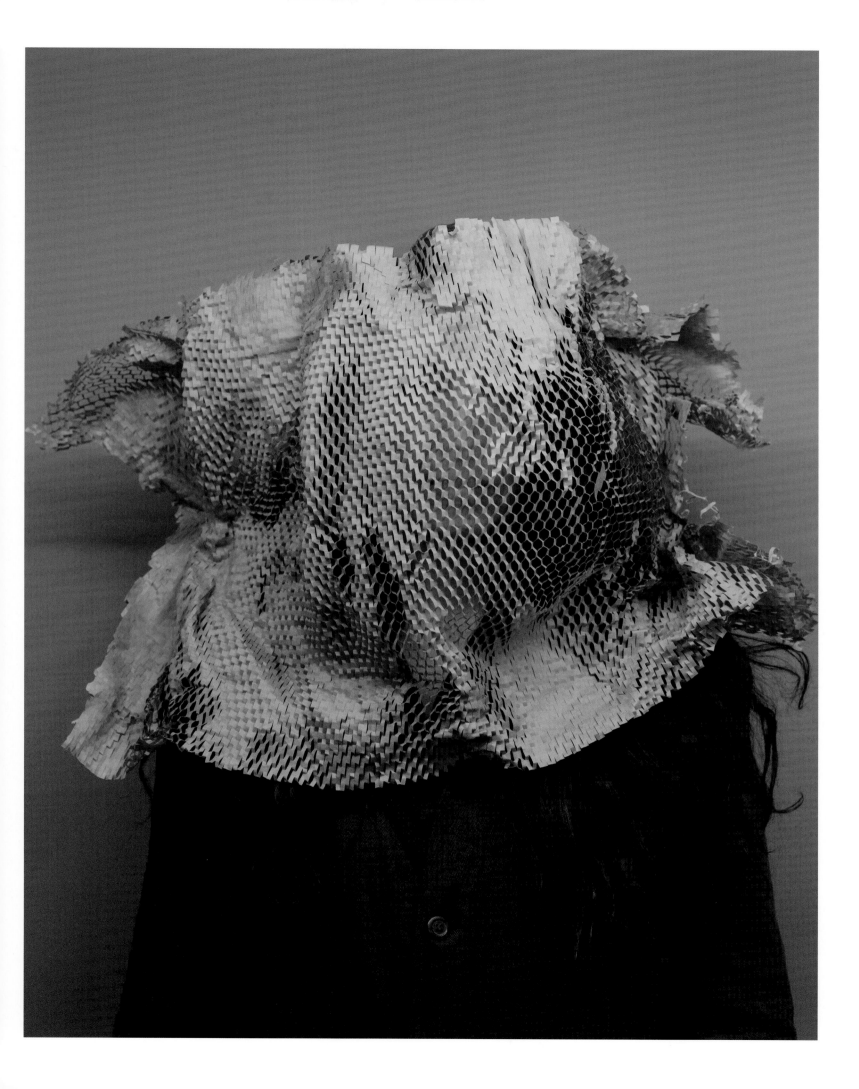

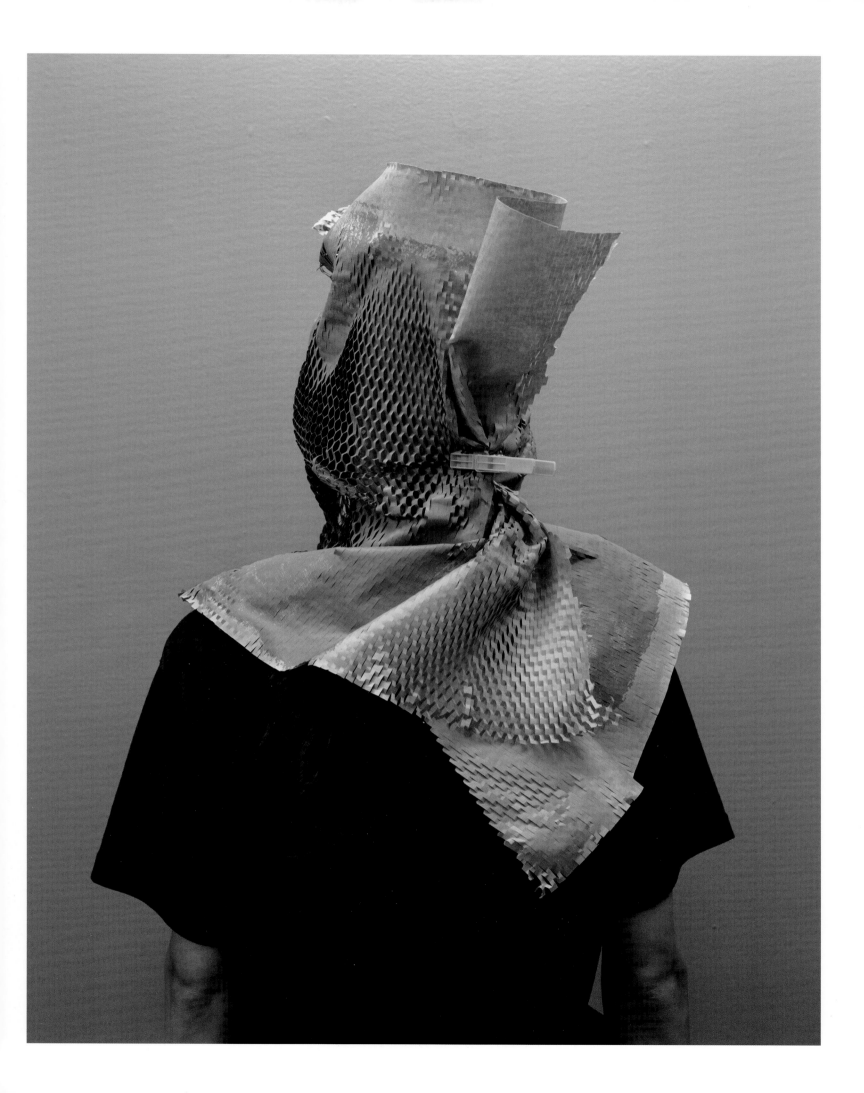

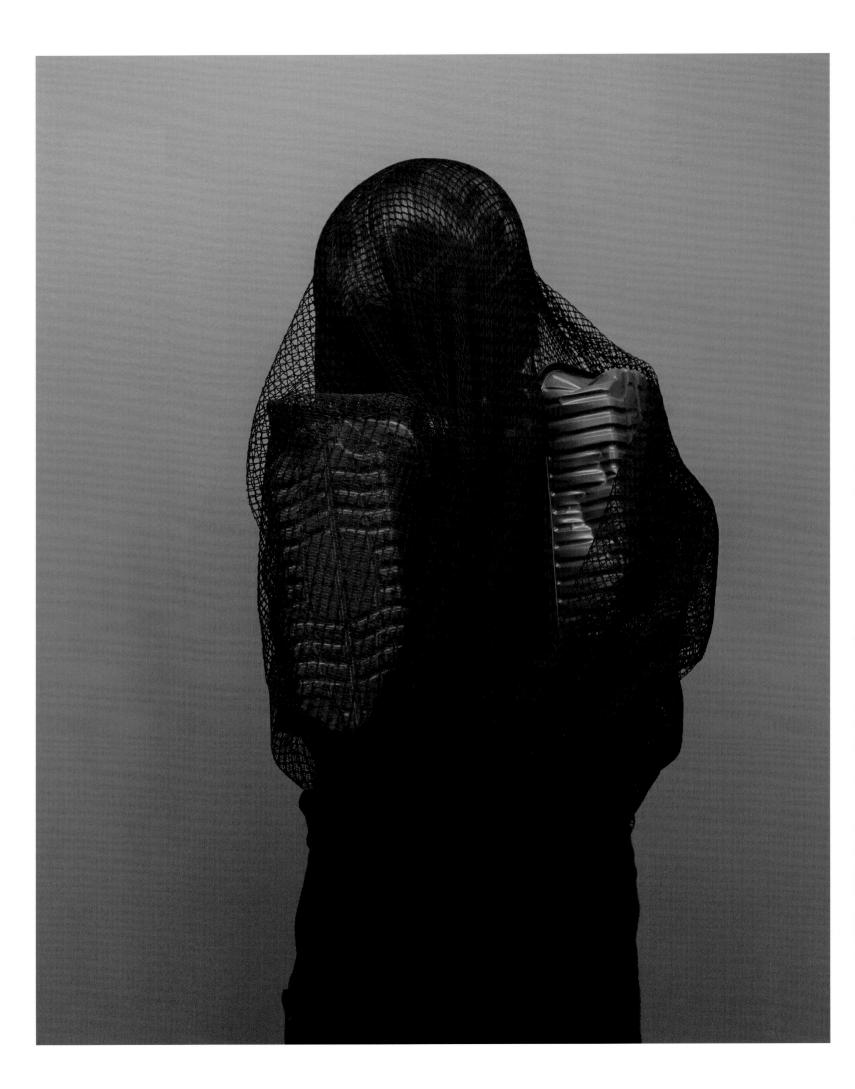

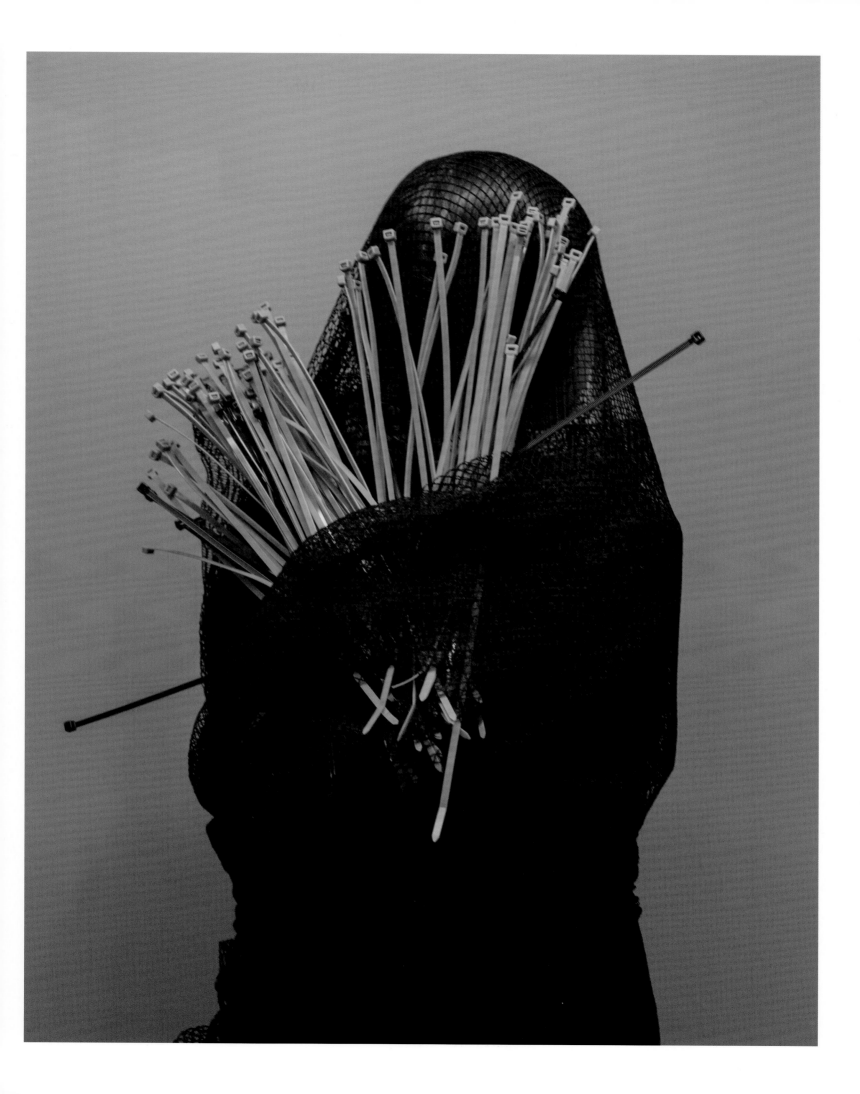

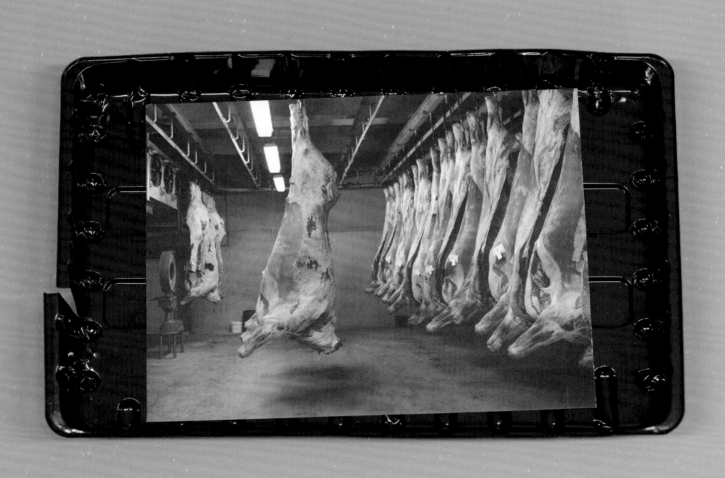

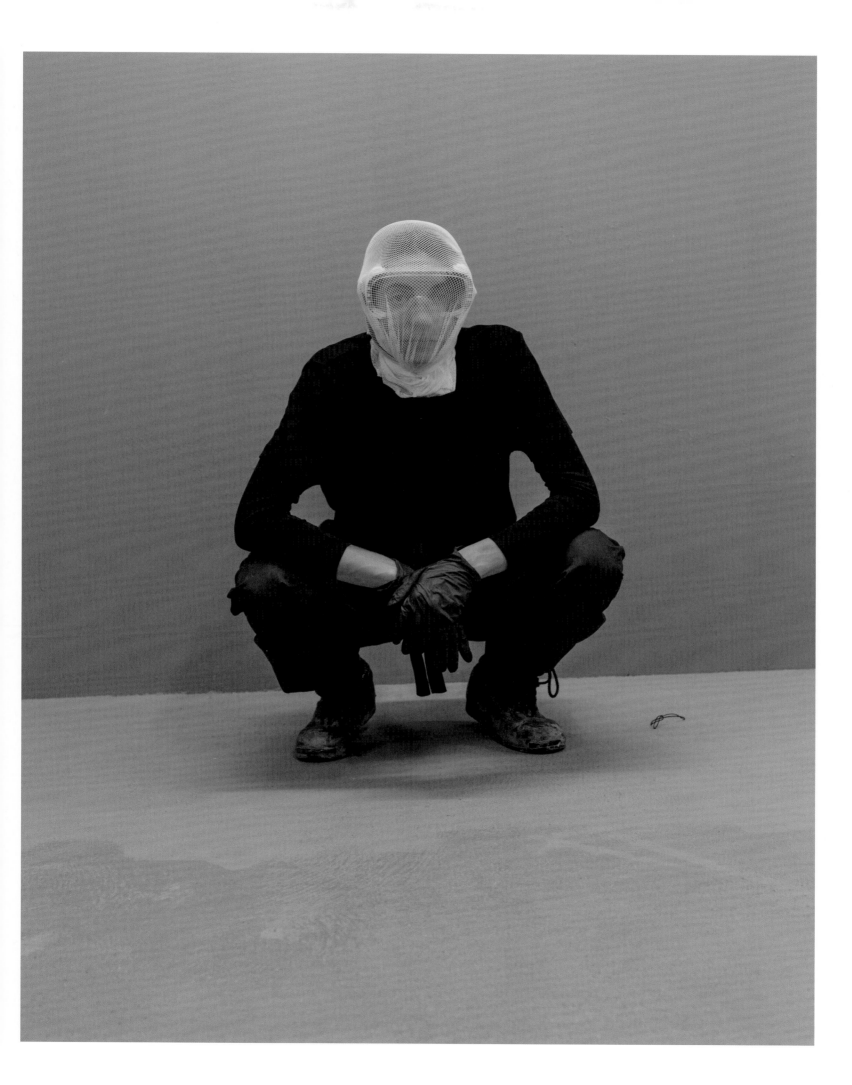

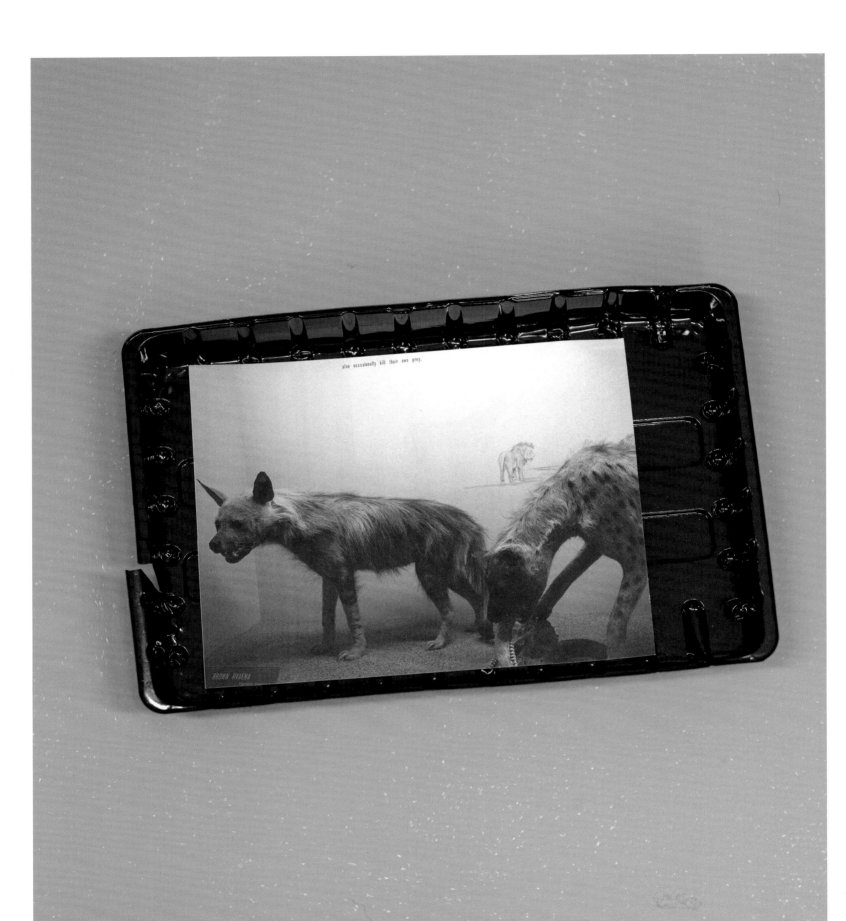

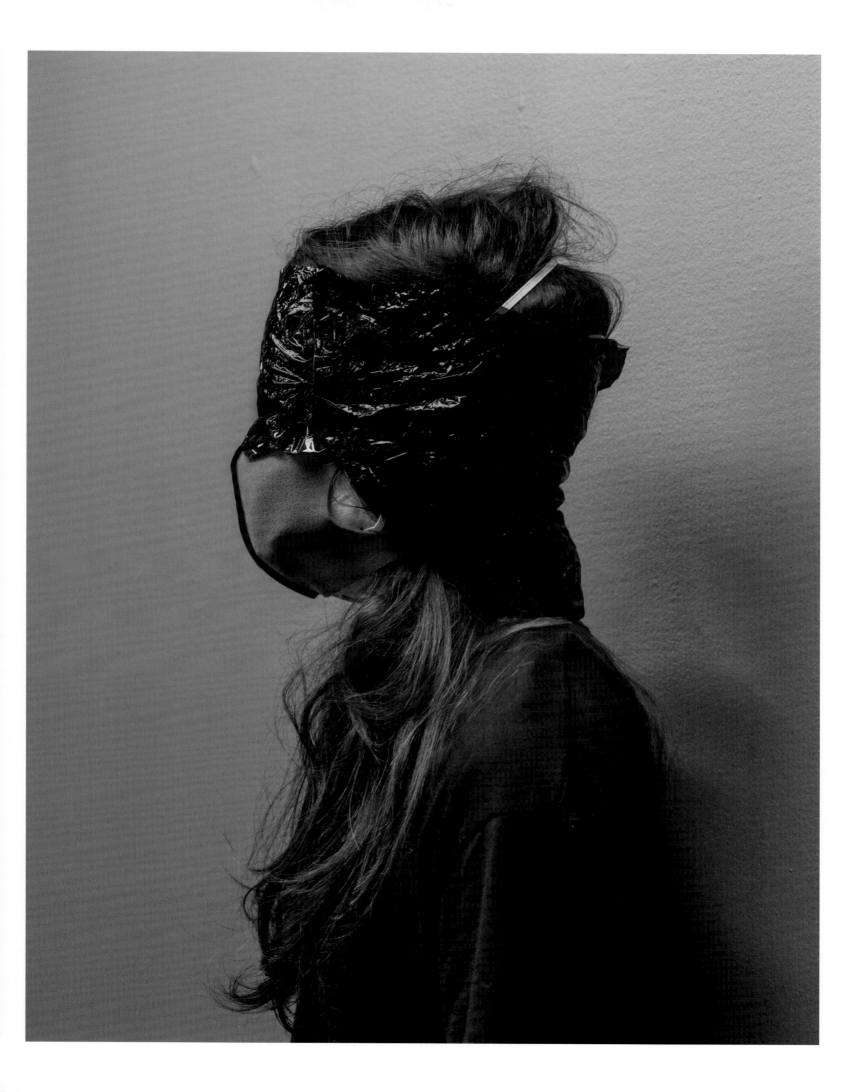

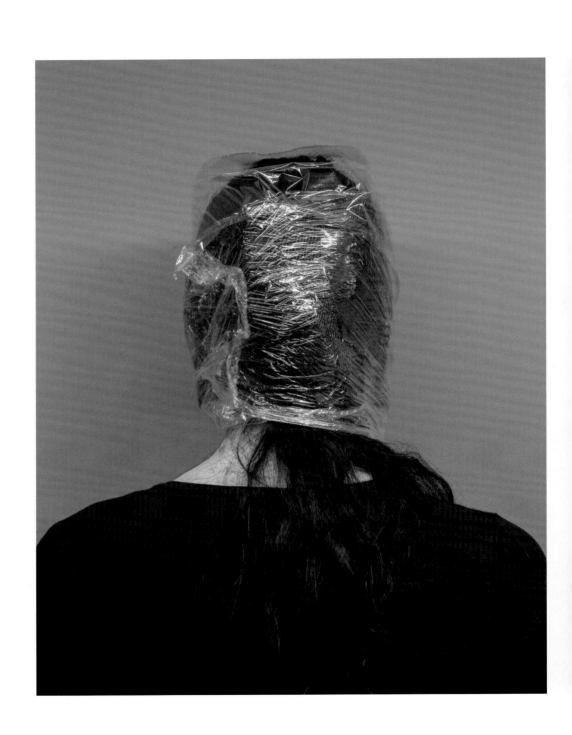

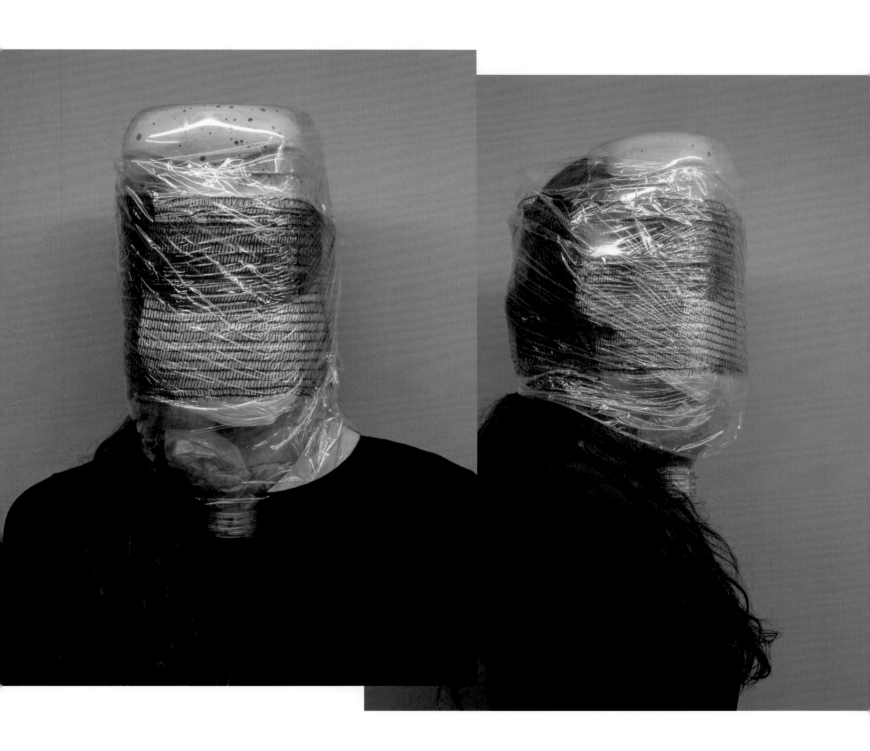

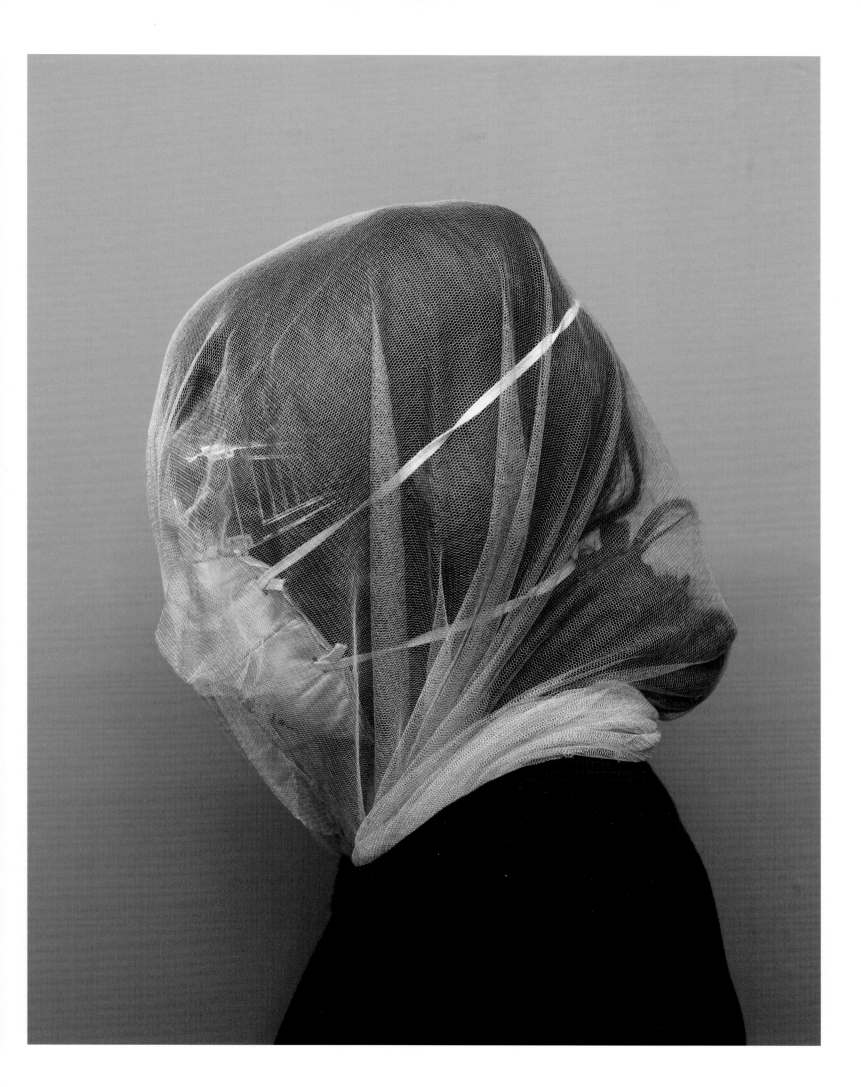

Pink Head, 2019
spray painted shock absorbent die cut kraft and tissue paper, T-shirt, masking tape, figure

Reservoir, 2019 (triptych)
shade material, galvanized wire, reinforced polyethylene liner, algae

Runway, 2019 (diptych)
one-way vision self adhesive vinyl

Hybrid I, 2019
5.5 mm panda film, wood frame, medical scrubs, T-shirt, figure

Supermarket Mask, 2019
polyethylene terephthalate food container, synthetic jersey mesh, T-shirt, figure

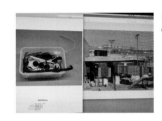

IMGP2964.jpg, 2019
computer screen

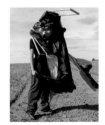

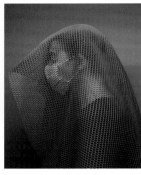

Red Net, 2019
polyester mesh fabric, surgical mask, T-shirt, figure

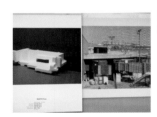

IMGP3145.jpg, 2019
computer screen

Hybrid II, 2019 (triptych)
5.5 mm panda film, wood frame, medical scrubs, T-shirt, figure

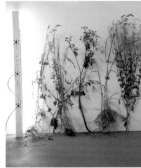

Weeds I, 2014
fluorescent lighting fixture, gaffer tape (polyethylene, polyester, synthetic rubber), plants

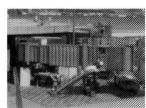

Airside I, 2019
one-way vision self adhesive vinyl

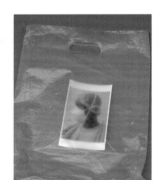

Virus I, 2019
colour photograph, plastic bag

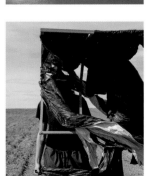

Hybrid III, 2019
5.5 mm panda film, wood frame, medical scrubs, T-shirt, figure

Airside II, 2019
one-way vision self adhesive vinyl

Virus II, 2019
colour photograph, plastic bag

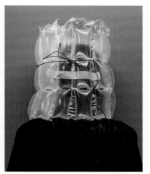

Clear Head, 2019
air cushion packaging, string, masking tape, T-shirt, figure

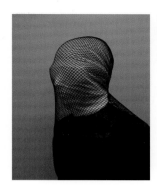

Chimera II, 2019
nylon micro mesh, T-shirt, polycarbonate safety glasses, figure

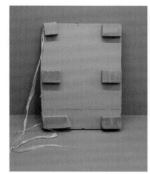

Pallet I, 2019
cardboard goods pallet, plastic wrap

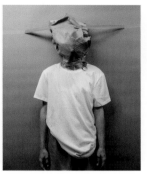

Pink Head II, 2019
spray painted shock absorbant die cut kraft and tissue paper, medical scrubs, T-shirt, masking tape, figure

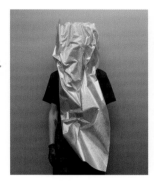

Gold, 2019
T-shirt, latex gloves, medical scrubs, air cushion packaging, adhesive-backed plastic vinyl polycarbonate film, figure

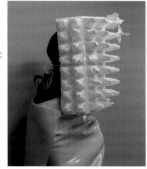

Seed Tray, 2019
plastic plug tray, string, self adhesive polyvinyl chloride material, T-shirt, figure

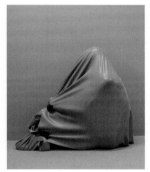

Wrapped, 2019
synthetic latex, gaffer tape, figure

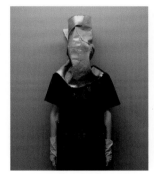

Grey Head I, 2019
T-shirt, latex gloves, grey emulsion paint, shock absorbent die cut kraft and tissue paper, medical scrubs, figure

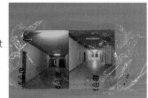

Funkhaus, 2019
colour photograph, printed cellophane

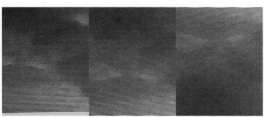

Sky, 2019 (triptych)
one-way vision self adhesive vinyl

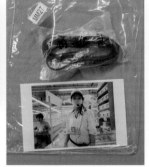

Supermarket, 2019
colour photograph, computer cable, printed plastic bag

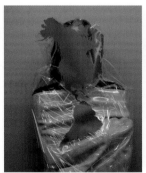

Map, 2019
self adhesive map, self adhesive polyvinyl chloride material, T-shirt, figure

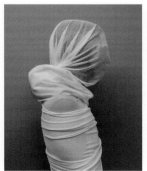

Chimera I, 2019
synthetic jersey mesh, nylon micro mesh, T-shirt, polycarbonate safety glasses, figure

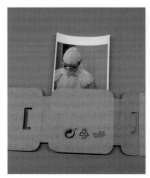

Virus III, 2019
colour photograph, printed cardboard packaging

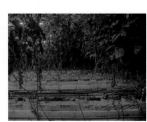

Tomato Plants I, 2014
LED lights, substrate, plastic irrigation tubes

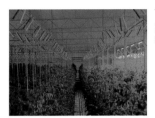

Tomato Plants II, 2014
plastic clips, synthetic string, LED lights

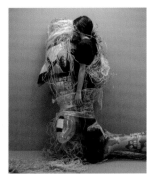

Shark, 2019
inflatable plastic fish, inflatable plastic shark, nylon cord, nylon string, plastic film, polycarbonate safety glasses, T-shirt, medical scrubs, figure

Root II, 2019
painted concrete, dead plant

Underground Farm I, 2014
polypropylene room, LED lights, stainless steel table top, plastic sheeting, plastic hose, plastic irrigation pipes, plastic bucket, wooden peg, nylon cable ties, fluorescent lighting fixture, micro herbs

Pallet II, 2019
cardboard goods pallet, plastic wrap

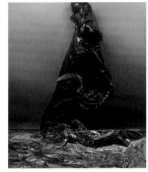

Blue, 2019
adhesive-backed plastic vinyl polycarbonate film, figure

Underground Farm II, 2019
colour photograph, printed cellophane

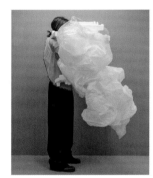

Cloud, 2019
plastic baby bib, medical scrubs, polystyrene, plastic packaging, figure

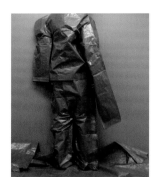

Suit I, 2019
laminated woven polypropylene tarpaulin, figure

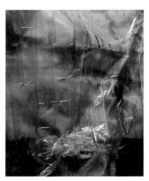

Blue-Green, 2019
painted shock absorbant die cut kraft and tissue paper, plastic sheet, surgical gown, latex glove, figure

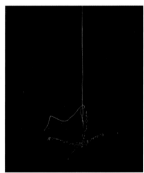

Root I, 2019
galvanized wire, shade material, plant

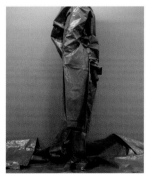

Suit II, 2019
laminated woven polypropylene tarpaulin, figure

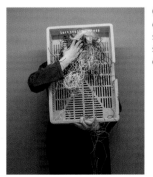

Crate, 2019
cotton string, plastic string, plastic crate, surgical gloves, cotton overall, figure

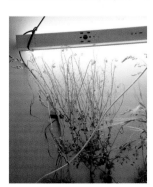

Weeds III, 2014
fluorescent lighting fixture, gaffer tape (polyethelyne, polyster, synthetic rubber), plants, synthetic rubber irrigation piping

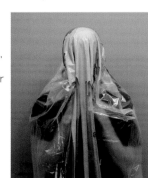

Paint, 2019
plastic sheet, emulsion paint, T-shirt, figure

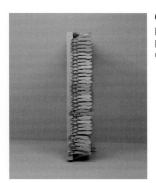

Grip, 2019
painted wood frame, polypropylene plastic clothes pegs

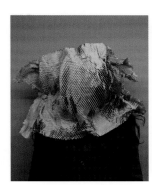

Veil, 2019
shock absorbant die cut kraft and tissue paper, overalls, figure

Shield, 2019
synthetic jersey mesh, T-shirts, scrubs, latex gloves, polycarbonate safety glasses, figure

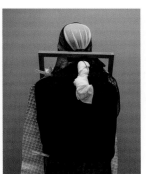

Yoke, 2019
synthetic jersey mesh, nylon micro mesh, T-shirt, polycarbonate safety glasses, painted wood frame, printed paper, polypropylene plastic clothes pegs, figure

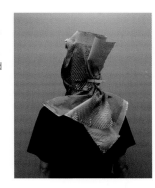

Grey Head II, 2019
T-shirt, grey emulsion paint, shock absorbent die cut kraft and tissue paper, plastic clothes peg, figure

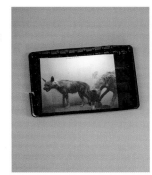

Brown Hyaena, 2019
polypropylene food container, colour photograph

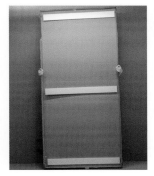

Packing, 2019
cardboard, polystyrene, latex gloves, figure

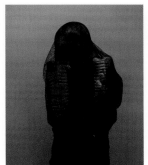

Relict I, 2019
synthetic jersey mesh, polypropylene food containers, figure

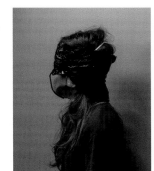

Isolation, 2019
cellophane, nanofiber mask, dust mask, T-shirt, figure

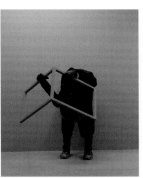

Chevron, 2019
blue emulsion paint, wood, latex gloves, medical scrubs, T-shirt, figure

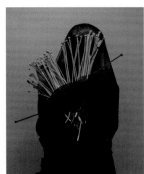

Relict II, 2019
synthetic jersey mesh, nylon cable ties, figure

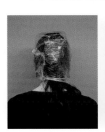

CS, 2019 (triptych)
spray painted shock absorbent die cut kraft and tissue paper, T-shirt, masking tape, figure

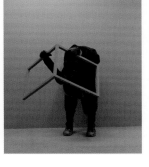

Shaded Head, 2019
shade material, polypropylene plastic clothes pegs, T-shirt, figure

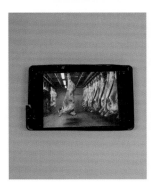

Abattoir, 2019
polypropylene food container, colour photograph

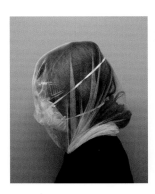

Chimera III, 2019
dust mask, silk mesh, T-shirt, polycarbonate safety glasses, figure

Thanks to

Carolina Aguirre Barrandeguy, Jack Shainman, Claude Simard, Joeonna Bellorado Samuels, Tamsen Green,
Toyin Ojih Odutola, Kevin Gurry, Aidan Dunne, Helen Rock, Sean O'Toole, Dan Thawley, Toyin Ojih Odutola, Kim Jones,
Thibo Denis, Janosch Mallwitz, Hans Schwarz, Lorna Brennan, Caoilfhionn Walsh, Neil Gurry, Andy Moores, Dan Archer,
Lily Breuer, Pierre Lequeux, John Doyle, Niklas Bildstein Zaar.

Design
Kevin Gurry

Production
Jens Bartneck / Kerber Verlag

Project Management
Verena Simon / Kerber Verlag

Printed and published by
Kerber Verlag
Windelsbleicher Str. 166–170
33659 Bielefeld
Germany
+49 521 950 08 10
+49 521 950 08 88 (F)
info@kerberverlag.com
kerberverlag.com

Kerber publications are distributed worldwide:

ACC Art Books
Sandy Lane
Old Martlesham
Woodbridge, IP12 4SD
UK
+44 1394 38 99 50
+44 1394 38 99 99 (F)
accartbooks.com

Artbook | D.A.P.
75 Broad Street, Suite 630
New York, NY 10004
USA
+1 212 627 19 99
+1 212 627 94 84 (F)
artbook.com

AVA Distribution / Scheidegger
Obere Bahnhofstr. 10A
8910 Affoltern am Albis
Switzerland
+41 44 762 42 41
+41 44 762 42 49 (F)
avainfo@ava.ch

KNV Zeitfracht
Distribution
kerber-verlag@knv-zeitfracht.de

The Deutsche Nationalbibliothek lists this publication in the Deutsche Nationalbibliografie: dnb.de.

ISBN 978-3-7356-0734-8

www.kerberverlag.com

Printed in Germany